IMAGES
of America

CHESTNUT HILL
REVISITED

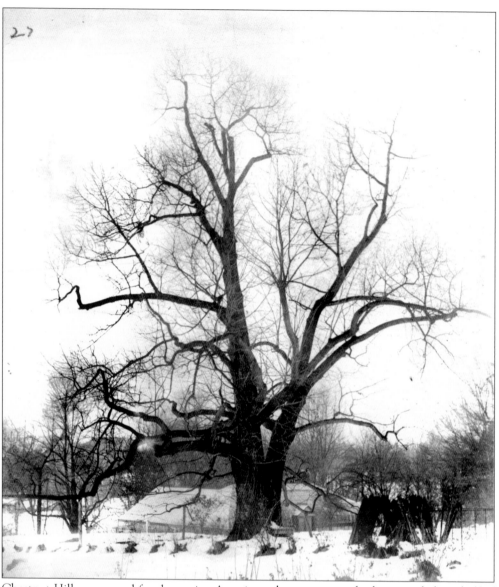

Chestnut Hill was named for the native American chestnut tree, which covered about half of the area's wooded hillsides when European settlers first came to Pennsylvania. This magnificent specimen stood in front of the Palm House at what became the Morris Arboretum c. 1910. The fernery is beside this site today. The chestnut blight rapidly devastated the species, and by 1920, most of these giants were dead or were dying. (Morris Arboretum.)

IMAGES
of America

CHESTNUT HILL
REVISITED

Elizabeth Farmer Jarvis
for the Chestnut Hill Historical Society

ARCADIA

ISBN 0-7385-3527-3

First published 2004

Published by Arcadia Publishing,
an imprint of Tempus Publishing Inc.
Portsmouth NH, Charleston SC, Chicago,
San Francisco

Printed in Great Britain

Library of Congress Catalog Card Number: 2003116328

For all general information, contact Arcadia Publishing:
Telephone 843-853-2070
Fax 843-853-0044
E-mail sales@arcadiapublishing.com
For customer service and orders:
Toll-free 1-888-313-2665

Visit us on the Internet at www.arcadiapublishing.com

On the cover: Springside School students gather in 1910 at the school's second home, on the corner of Chestnut Hill and Norwood Avenues. The house at 8810 Norwood Avenue, behind them, is now gone. Near the front right, 10-year-old Clarissa Smythe wears a white dress with a dark tie. A lone boy sits at the front left. At this time, a few boys were admitted to the youngest grades of this girls' school. (Springside School.)

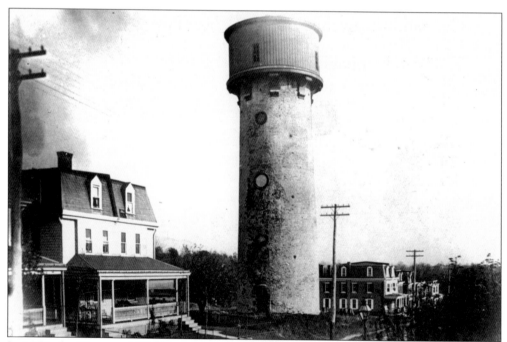

In 1859, the Chestnut Hill Water Company built this water tower, pictured *c.* 1906. A 1917 storm destroyed the wood tank at the top. (Germantown Historical Society.)

CONTENTS

ACKNOWLEDGMENTS

Scores of knowledgeable contributors impressed me with their affection for our community. Peter Lapham, executive director, and the board of the Chestnut Hill Historical Society endorsed this second book. We are indebted to Richard Wood Snowden for financial support. Rosemary Lord wrote captions for the Wissahickon chapter. Margaret Kirk shared her research on the Chestnut Hill Hospital and contributed those captions. David Contosta's books were the starting points for this book. *The National Register of Historic Places Inventory for Chestnut Hill,* by Jefferson M. Moak, and all Moak's research were an invaluable resource. Contosta and Moak, as well as Thomas Keels, provided text commentary. Joan Saverino offered insights into the Italian American community. Susan Schindler contributed disciplined text editing. Train and trolley experts Janet Potter and Andrew Maginnis sorted out the terminology and facts related to this intricate subject. Joseph B. Van Sciver III dated photographs using his astonishing familiarity with early automobiles. Audrey Simpson scanned more than 100 images and devoted hours to mailings and accounting. Dena Dannenberg completed research at other institutions. Christopher Lane and the Philadelphia Print Shop staff allowed us to get in their way and use their scanner. David Kerper and Marc McCarron of Kerper Studio Inc. kept track of scores of photographs in a bewildering number of formats. The following institutions loaned photographs: the Athenaeum of Philadelphia, Atwater Kent Museum, Chestnut Hill Academy, *Chestnut Hill Local,* Free Library of Philadelphia, Germantown Historical Society (including the Italian American Collection), Historical Society of Pennsylvania, Library Company of Philadelphia, Library of Congress, Morris Arboretum and Nursing History Center (both of the University of Pennsylvania), Philadelphia City Archives, City of Philadelphia Water Department, and Springside School.

Thanks to all who contributed photographs or information: Dolores Barrosse; William Bassett; Margaret Biddle; David Bower; Mary Campbell; Jack Carpenter; Jim Casale; Stephen Corson; Gina Cossman; Mary Dabney; Jack Donnelly; John, Regina, Timothy, and William Dwyer; George Filippi; Elaine Galante; Hugh Gilmore; Rose Gunson; Robert Gutowski; Helen Henry; Raymond Holstein; Naomi Houseal; Sonny Intrieri; Sally Jarvis; Lela Kerr; Lou Ann Kolb; Winnie Lear; Karen Lorenzon; Ellen Maher; Cheryl Massaro; Judy McLaughlin; Rudy Miles; Buddy Morasco; Molly Mullee; Wendy Nelson; Ruth Peckman; Susan Pizzano; F. Markoe Rivinus; Rosie Rosa; Marion Rosenbaum; Carol Cameron Sears; Elizabeth Serianni; Gerry Serianni; Elizabeth Shellenberger; Robert Skaler; Sarah L. O. Smith; Richard Snowden; Joel Spivak; Anne Marie Staffieri; Edward Stainton; Linda Stanley; Deborah and Morris Stout; Avery Tatnall; Rev. Hal Taussig; Joseph Thomas Jr.; Joan Wallick; William Wilson; Barbara Woodling; Katie Worrall; Ruth Worthington; and Mike Yanni. Photographs are from the collection of the Chestnut Hill Historical Society unless otherwise credited.

I appreciate Judy, Anne, and Alex Jarvis for their typing and observations about their hometown. Andrew Jarvis, with a keen eye for buildings and topography, and an elegant way with words, was invaluable.

INTRODUCTION

Chestnut Hill today bears little resemblance to the way it looked 150 years ago, even though many buildings survive from before that time. In 1854, Chestnut Hill was an isolated farming and milling community 10 miles from the center of Philadelphia. The two main roads, Germantown Avenue and Bethlehem Pike, had become important toll roads on which people in outlying areas brought goods to market. Even before the first railroad was opened to Chestnut Hill in 1854, affluent citizens from downtown Philadelphia had discovered the rural beauty of Chestnut Hill and began to spend the summer months here. Their ornate villas stood prominently among the farms and pastures that surrounded the village, with its houses and barns dating to the 18th century.

The availability of open space and the Chestnut Hill Railroad made Chestnut Hill an ideal site for the one of the largest military hospitals of the Union during the Civil War. Mower General Hospital was a small city itself, where physicians and nurses cared for 20,000 wounded soldiers from 1863 to 1865.

Pennsylvania Railroad executive Henry Howard Houston influenced Chestnut Hill's future perhaps more than any individual. As early as 1880, he began buying large tracts of land in the western part of Chestnut Hill to realize his vision of a planned community. He convinced the Pennsylvania Railroad to open a second line through his holdings in 1884, which enabled his creation of a new residential community. Houston's daughter Gertrude and her husband, Dr. George Woodward, continued the carefully orchestrated development of Chestnut Hill beginning in 1904. As more affluent families came to settle in Chestnut Hill, the Woodwards engaged several talented young architects to design American versions of French and English stone country houses for the expanding community. The Woodwards also planned many new roads, parks, and civic facilities.

By 1880, Chestnut Hill had become home to some of America's most affluent and socially elite families. These families commissioned prominent architects to design their houses in the latest styles, leaving Chestnut Hill with a rich architectural legacy.

Chestnut Hill was also a destination for immigrants. Stonemasons and quarrymen from Italy came to build the splendid estates. Irish families escaping poverty worked as domestic servants, gardeners, and chauffeurs. People of all backgrounds crossed paths on Germantown Avenue, where shopkeepers saw to the needs of the rich and the modest alike. This busy artery was Chestnut Hill's link to downtown Philadelphia. Trolleys ran down the avenue, allowing anyone to travel all over the region on the spiderweb of connecting streetcar lines.

The Wissahickon Creek, on Chestnut Hill's western boundary, served to isolate the village and to preserve natural space. It was this partially rural setting with its fresh air and open space that attracted hospitals to the area, particularly for tubercular patients and those with mental disorders. At the start of the 20th century, the citizens of the growing community recognized the need for a local general hospital, and thus the Chestnut Hill Hospital was founded in 1904.

The Great Depression changed Chestnut Hill forever. Many of the area's affluent residents lost their wealth or jobs after the stock market crash of 1929, and their losses filtered down to the shopkeepers, builders, and servants whom they could no longer afford to pay. Some mansions became too costly for their owners to maintain and were demolished. Families found new occupations and adapted to their circumstances as best they could until the economy gradually revived.

During the two world wars, Chestnut Hill families of all backgrounds saw their sons, brothers, and husbands go overseas in military service. Listed on memorial plaques, the last names of those who served reflect the diversity in national origin of Chestnut Hill citizens at the middle of the 20th century.

In the 100 years from 1854 to 1954, Chestnut Hill was transformed from a farming community of mainly English and Germanic origin to an urban village of 20,000 people of diverse national backgrounds. Chestnut Hill may appear today to be a place where change occurs slowly, but its history has been one of continuous expansion and renewal.

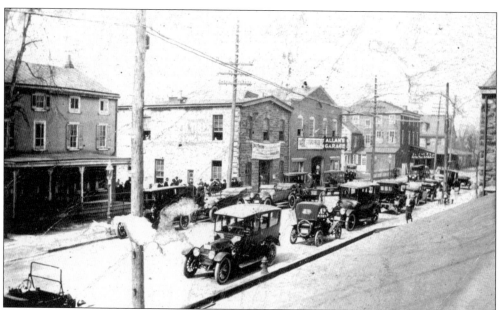

This is the first block of West Highland Avenue c. 1915 to 1918 on the day of a dog show. The Chestnut Hill Parking Company demolished the building to the left, 25–27 West Highland Avenue, for a lot in 1956. Allan's Garage (owned by Alexander Allan) is in the center, built in 1894, its facade now redesigned with a false roof. The building to its left was McCormick's stable and is now a Wawa market. (Jack Donnelly.)

One

GERMANTOWN AVENUE AND BETHLEHEM PIKE

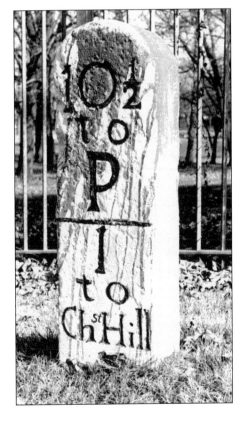

Germantown Avenue and Bethlehem Pike were the first two segments of the King's Highway, the pre-Revolutionary main road carrying people and their goods between Philadelphia and the north. Germantown Avenue began at Front Street by the Delaware River and continued nine and one-half miles to the top of Chestnut Hill. There, the King's Highway continued on what is now called Bethlehem Pike. This milestone beside Bethlehem Pike at Bells Mill Road in Erdenheim marked the mileage to Philadelphia.

In 1884, the approach to Chestnut Hill on Germantown Avenue was unpaved. In the 1890s, citizens subscribed to the Village Improvement Association, which maintained a water wagon to settle the dust. Cresheim Creek flowed under the stone bridge in the foreground. The house beyond the creek was once part of the village of Cresheim. This house stood at what is now the entrance to Cresheim Valley Drive, where the pergola and water trough are located. (Library Company of Philadelphia.)

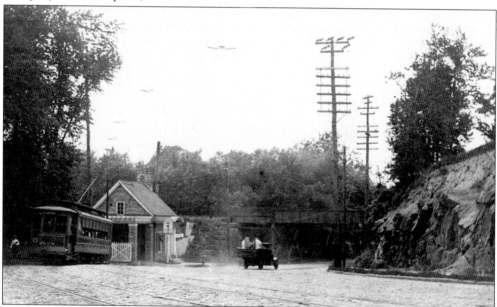

Martin's Coal Company was beside the Fort Washington branch of the Pennsylvania Railroad, just beyond its junction with the present-day R8 SEPTA line. Tall poles carried power for trolleys and streetlights. Pictured between 1910 and 1920, this streetcar could operate from both ends and did not need a turnaround loop to change directions. On the right is a large outcrop of Wissahickon schist, also called Chestnut Hill stone, which was later quarried down to street level. (Germantown Historical Society.)

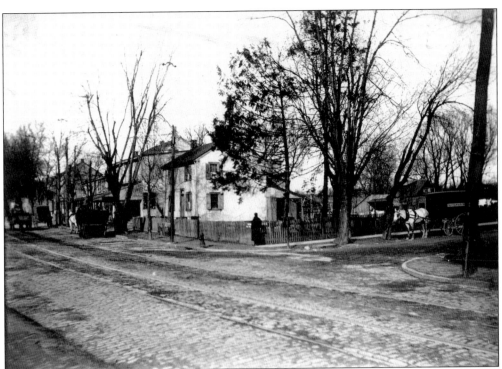

The two houses at the northeast corner of Germantown Avenue and Mermaid Lane, pictured here in 1908, were built before 1876. These houses and the 18th-century Mermaid Hotel (out of picture to the right) had been torn down by 1911 to make way for an extension of Cresheim Valley Drive, today called Winston Road. George Woodward planned this new thoroughfare on the path of a streambed to open the east side of Chestnut Hill for development. (Germantown Historical Society.)

This view looks north up Germantown Avenue toward the corner of Springfield Avenue c. 1908. The Houston estate bought the house in the foreground and demolished it before 1923 to widen Springfield Avenue. From 1904 to 1934, the building on the northwest corner of Germantown and Springfield Avenues housed Charles Tomlinson's store, which sold yard goods, kerosene, candy, hay, and other general goods—a must stop for neighborhood youngsters with a penny to spare. (Robert Skaler.)

11

A woman shields herself from the rain c. 1925 in front of 7841 Germantown Avenue, at Springfield Avenue, the site of Russell Aiman's meat store. The building was built between 1849 and 1861; its mansard roof was added later. The Aimans lived above the store and entered through the gate in the picket fence on the right. Aiman's delivered groceries to rich and poor alike. Since 1956, Margaret McGettigan has run the Chestnut Hill Launderama at this location.

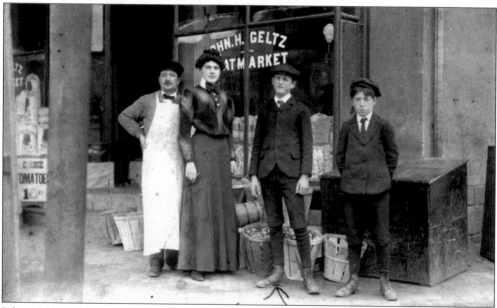

John Geltz and his wife stand in front of their market, at 8036 Germantown Avenue, which later became the site of Galante's (see page 93). The boy second from the right in this c. 1910–1915 view is Cephas Livezey. The boy on the right may be John H. Geltz Jr., who later took over the business. By 1935, there were 15 grocery stores and meat markets in Chestnut Hill, reflecting the fact that most households, many without refrigeration, needed to buy groceries nearly every day.

William Depetris, a sculptor and builder from Naples, constructed this model of the Chestnut Hill water tower, seen here in the early 1940s. The model stood as a curiosity for many years outside his shop in a horse pasture. Today, it resides in the backyard of 47 West Highland Avenue. The gas station beyond was built in 1937. The Chestnut Hill Hotel, before its remodeling, and the Jenks School loom in the background. (Jack Donnelly.)

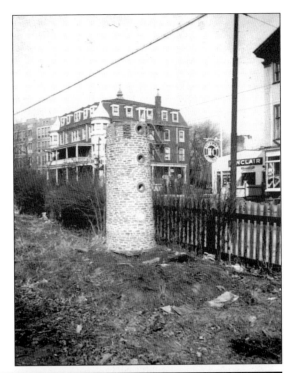

This house stood on the northwest corner of Germantown Avenue and Hartwell Lane. Henry Kerper bought it in 1818, and it remained in the family for over 130 years. Caroline Kerper, a schoolteacher at the Jenks School, lived here all her life. Her students considered her old-fashioned, still wearing the high-necked, long dress of her youth. She never installed heat or electricity in her house and drew water from a pump in the backyard. The house was demolished in 1950.

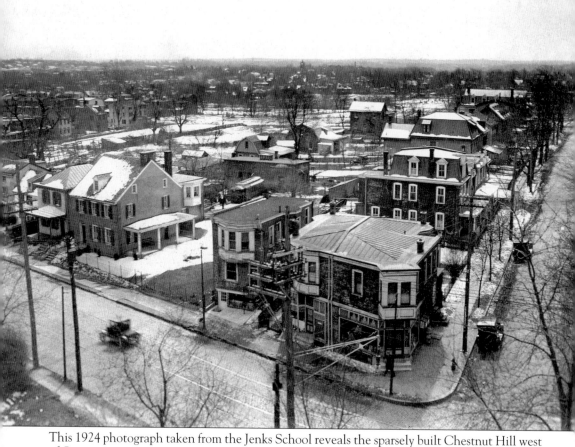

This 1924 photograph taken from the Jenks School reveals the sparsely built Chestnut Hill west of Germantown Avenue. The little house second from the left, 8220 Germantown Avenue, was built in 1744 and is possibly the oldest surviving house in Chestnut Hill. To the right of that house is 8224 Germantown Avenue, followed by 8226 Germantown Avenue, the former home of Carol Deshon. In the backyard of the Deshon house is the retired J. G. Brill Company streetcar that Deshon bought c. 1915 for his children to play in. The trolley was a landmark along Germantown Avenue until 1950, when it was removed to make way for a terrace. In the center foreground is 8232 Germantown Avenue, built in 1914 by Raffaele Casale, who built row houses in the Mayfair neighborhood of Philadelphia. (Stephen Corson.)

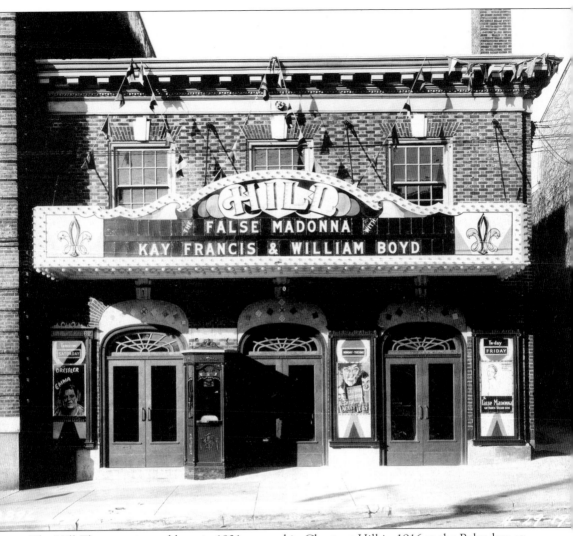

The Hill Theater, pictured here in 1931, opened in Chestnut Hill in 1916 as the Belvedere at 8320 Germantown Avenue. Its Georgian Revival–style facade was masked by a sleek Art Deco covering in 1936. One former Chestnut Hill resident remembers sneaking into the theater through the side door in the 1930s as a child. The theater was torn down in 1973 to make way for an addition to the Bell Telephone building. (Athenaeum of Philadelphia.)

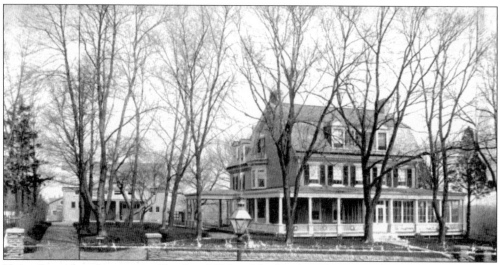

Henry Lentz bought a tract of land in 1827 and built a large house at the northeast corner of Germantown Avenue and Southampton Street. On this property he ran a marble yard, selling tombstones and other marble products. The Johnstone family lived here in the 1880s. The property was later called Hampden Place. By 1904, it had become the Shady Hill Country Day School, which moved to 8836 Crefeld Street in 1922. In 1921, the local board of education purchased the house and demolished it to build the John Story Jenks School. The stone wall that bordered the property is still there. Below is the Christmas dinner table in the conservatory c. 1890, with tall marble gaslights and fine crystal. (Above, Germantown Historical Society.)

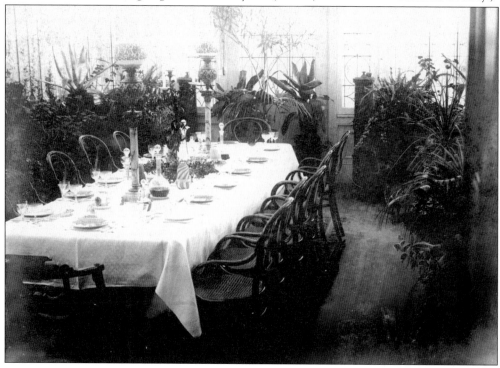

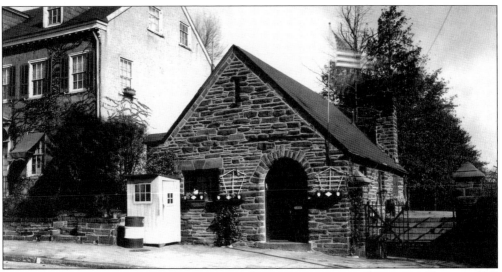

In 1904, the Philadelphia Water Department began pumping treated water to Chestnut Hill from the Schuylkill River via Roxborough. This booster pumping station of the Philadelphia Water Department was built in 1923 just north of the Jenks School playground. The pumping station, pictured in 1943, still brings water to Chestnut Hill. Today, electronic controls regulate water pressure, pumping more water to Chestnut Hill around 7:00 a.m. in time for morning showers. (City of Philadelphia Water Department.)

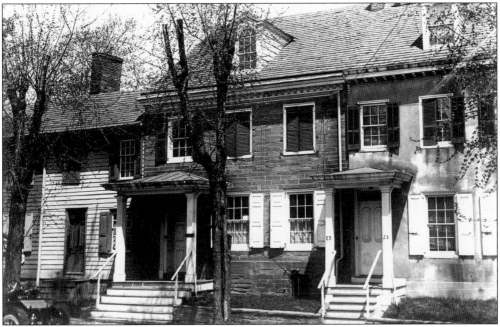

By 1798, carpenter Wigard Jacoby had built the house in the center, 8327 Germantown Avenue. Even though it has some of the finest woodwork details found in a Federal house in Philadelphia, the building was abandoned and allowed to deteriorate for 30 years. In 1947, Merle and Richard Chamberlain and Gertrude Woodward saved the house from demolition. The frame house is gone, and the one on the left, 8331 Germantown Avenue, is stuccoed. (Library of Congress.)

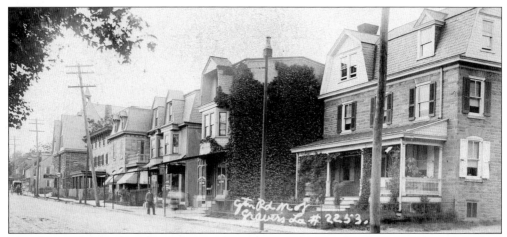

The Graver family, for whom Gravers Lane is named, owned a farm stretching east from Germantown Avenue to the railroad tracks. In 1893, the Gravers built this corner house at 8401 Germantown Avenue, pictured *c.* 1908. John Graver Johnson delivered hats for his milliner mother, Elizabeth Graver Johnson. Fabulously successful as a lawyer, he collected artwork, now the John G. Johnson Collection at the Philadelphia Museum of Art. In 1910, the house's porch was replaced with a storefront. (Hugh Gilmore.)

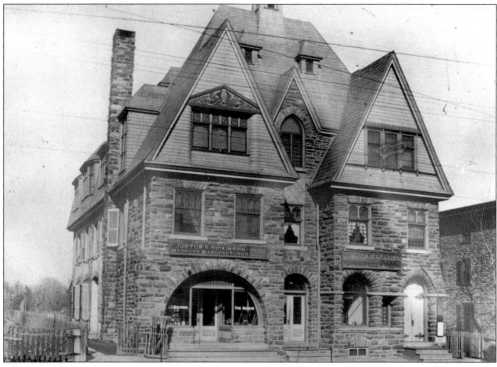

The Knights of Pythias fraternal order built its Perseverance Lodge in 1889 at 8425–8427 Germantown Avenue. Several fraternal orders met there. It later became the Masonic Hall. George Pearson designed this lively facade, which was much modified in 1960 to conform to the Chestnut Hill Development Group's efforts to give the Victorian building a "colonial front." Pictured between 1889 and 1906, Justus D. Dickinson Harness Manufacturer made fine saddles, bridles, harnesses, and the like and repaired trunks.

The Bank of America was the first bank in Chestnut Hill in 1886. It opened in the rented front room of 8433 Germantown Avenue. Built *c.* 1750, the house was one of the few houses to survive the British torching of the village in 1777. The bank received "nearly 15 dollars in deposits" on opening day. Scandal rocked Chestnut Hill when a bank director, Sen. John J. Macfarlane, disappeared with the assets of the bank a few years after it opened.

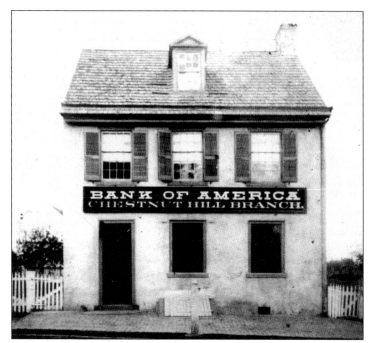

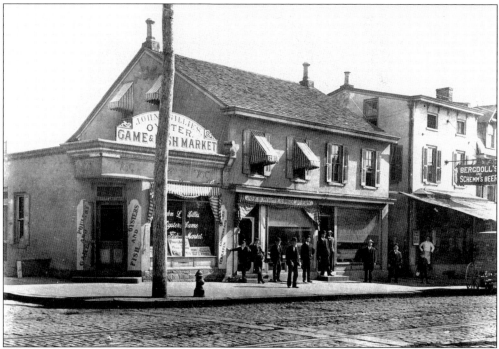

Established in 1886, John Gillies Oyster, Game, and Fish Market was a Chestnut Hill institution for 75 years. The market is pictured *c.* 1900 at the southeast corner of Evergreen and Germantown Avenues. John Gillies wore a fedora in winter and straw hat in summer. Bob Maddox, an African American man from Germantown, worked for Gillies for over 50 years. When Gillies died in 1933, his three sons continued the business. Only the building on the right survives.

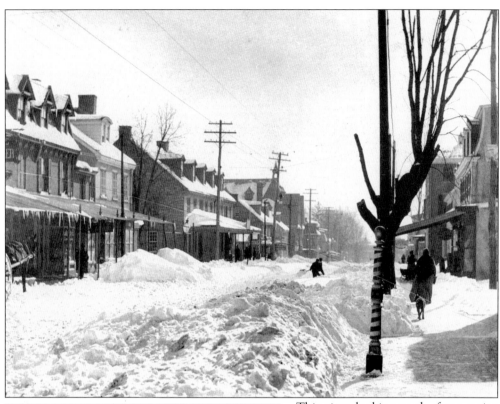

This view, looking south after a major snowstorm *c.* 1900, shows the 8500 block of Germantown Avenue, with a grocery store and restaurant that is now the Robertson Florists building. A barber pole in the foreground marks George Grebe's barbershop at 8530 Germantown Avenue, shown in the lower photograph. George Grebe built this brick store in 1897 across the street from his previous store, at 8527 Germantown Avenue, which he started in 1892. His father, Conrad Grebe, was the barber at the Mower Hospital for Civil War soldiers (see page 113). George Grebe sold "gent's wear" and cigars, among other things. He advertised in the newspaper, "Professor George Grebe's Herbine, a sage preparation for the hair and scalp. Promotes the growth of hair, stops its falling and cures all irritations of the scalp." The building on the right, 8532 Germantown Avenue, was built for Frank Streeper's drugstore in 1892.

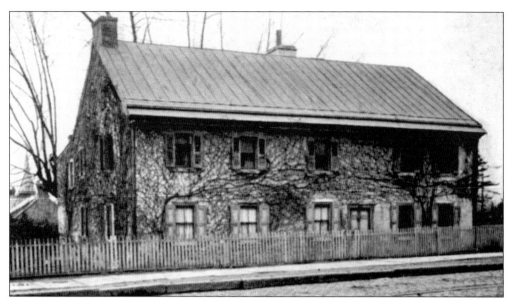

The Yeakel-Schultz house, built c. 1734, occupied the lot at the northwest corner of Germantown and Evergreen Avenues, pictured here before 1927. During the Revolutionary War in 1777, British soldiers wrecked the house and stole all the stored food and drink. Three generations of the Yeakel family lived there until 1879. The Pennsylvania Railroad built a station on the site of the barn. The station's spire, gone today, is visible in the left background. The house was demolished in 1929.

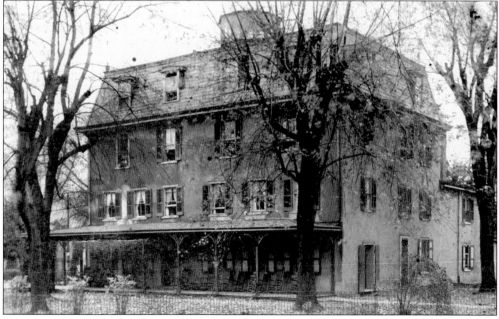

The Maple Lawn Inn, or "the Dust Pan," was a summer hotel. It opened in 1876 at the fork of Germantown Avenue and Bethlehem Pike, pictured c. 1908. It got its nickname from the dust generated by the roads. Two stories, a mansard roof, Victorian wood trim, and an observation tower were added to this Colonial building, formerly Yeakel's general store. Philadelphia Rapid Transit (PRT) bought the inn and then demolished it in 1927 to make a trolley loop.

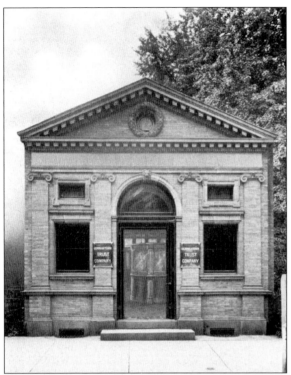

Pictured in 1914, this brick building at the southwest corner of Germantown and Rex Avenues is the Germantown Trust Company, designed by Cope and Stewardson in 1896. This bank branch relocated to Germantown and Evergreen in 1928. This facade was covered over in 1930. (Philadelphia City Archives.)

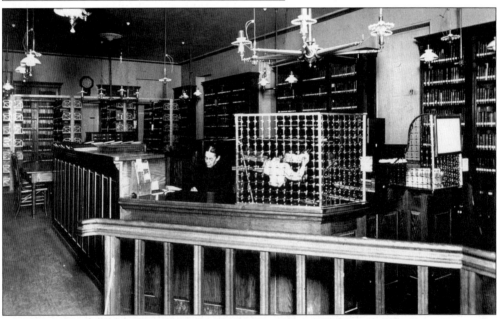

Librarians preside over the Christian Hall Library c. 1896. The library opened in 1871 on the site of the present Chestnut Hill branch of the Free Library of Philadelphia. One of the women may be Laura Wenner, who was assistant librarian for 48 years beginning in 1893. The library charter's aim was "to provide comfortable rooms, well supplied with attractive and instructive books, wherein the people of Chestnut Hill, without any distinction of age, sex, race, or color, may read and study."

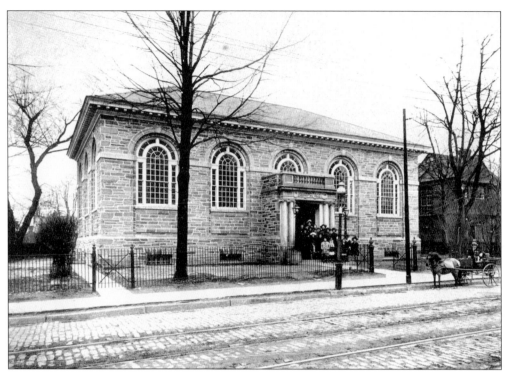

In 1897, the Free Library of Philadelphia took over the Christian Hall Library and in 1907 built this Georgian Revival–style branch, with stonework constructed by the Lorenzon brothers. To the right is the now vanished Shingle-style house and office of Dr. Robert Bolling, who was the assistant executive officer at the Mower General Hospital in Chestnut Hill during the Civil War. This house was later replaced by the trolley loop. Below is a 1911 view of the new library interior. (Below, Philadelphia City Archives.)

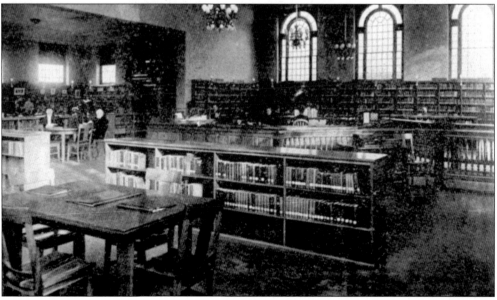

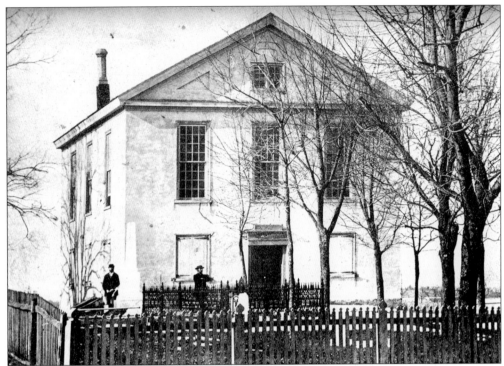

The Wesley Chapel Methodist Episcopal Church was built in 1845 at 8814 Germantown Avenue. George Rex sold them the chapel site and gave a donation toward the cost of the church. The obelisk on the left was for Richard Bessan, who died at age 52 in 1866. It is inscribed, "His sun set but it was yet noon" and still exists today behind the church along with other gravestones. In 1884, a new church was built. (Chestnut Hill Methodist Church.)

Jesse Kneedler came to Chestnut Hill in the 1840s and became one of the first commuters to downtown Philadelphia. Kneedler, who owned a wholesale dry goods company, lived downtown on Washington Square during the winter. He moved his family every spring to the 8800 block of Germantown Avenue, probably to one of these houses, shown c. 1866. He was driven every morning in his carriage to the nearest train station, then in Germantown. By the 1880s, he lived in Chestnut Hill year-round.

This 1860s house once stood where 8846 and 8860 Germantown Avenue are today. From 1914 to 1935, William Goodman Jr. and family lived there. Goodman was president of Harrington and Goodman Inc., a tailor trimmings business in downtown Philadelphia. In 1937, his daughter Jane Vanuxeum Goodman Carnevali made sure to show her daughters the vacant home in which she grew up before the house was to be torn down in 1939. (Rose Carnevali Gunson.)

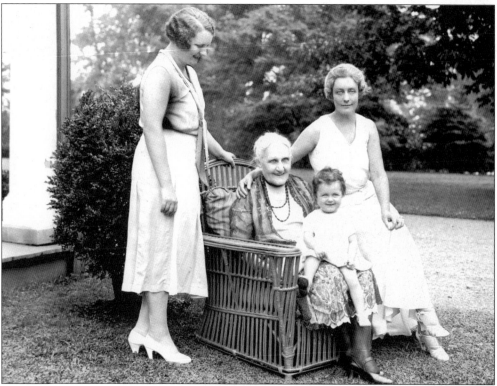

Four generations of Goodman women gather in the yard of the house pictured above in 1930. The matriarch is Sarah Abercrombie Goodman. Sarah became the wife of William Goodman Sr. in 1870. To the right is her daughter-in-law, Elizabeth Vanuxeum Potter Goodman, daughter of William Potter (see page 101), who married William Jr. in 1904. Elizabeth's daughter, Jane Carnevali, is looking at her one-year-old daughter, Rose Elizabeth Carnevali, on her great-grandmother's lap. (Joan Carnevali Wallick.)

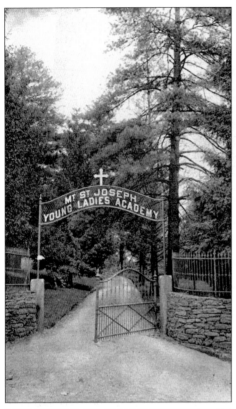

In 1858, the Sisters of St. Joseph purchased the seven-acre property of Joseph Middleton, founder of Chestnut Hill's Catholic parish, to establish Mount St. Joseph Young Ladies Academy. The academy was chartered in 1871. It drew 21 boarding students from as far away as New Orleans and Virginia, as well as from nearby Manayunk. The entrance sign, left, faced Germantown Avenue. A school for boys opened at Mount St. Joseph Academy in 1875. It later became Norwood Academy. Chestnut Hill College for women opened on the academy campus in 1924. In the view below, taken c. 1909, Germantown Avenue is seen on the left. The first academy building in the center was built in 1875. A larger school building, St. Joseph's Hall, six stories tall, was completed in 1903. (Historical Society of Pennsylvania, David Bower.)

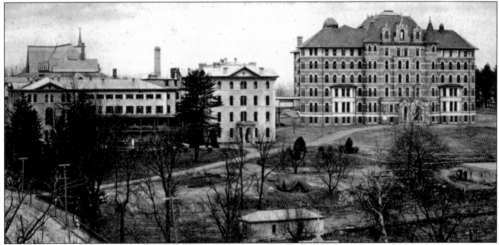

Edward Kolb emigrated from Germany to Philadelphia at age four in 1841. In 1875, his friends thought he was crazy when he bought 12 acres at the remote corner of Germantown and Northwestern Avenues. He opened Kolb's restaurant at what is now 5 Northwestern Avenue, right of center. It proved to be a fine place for a restaurant because two streetcar lines terminated at this corner. Passengers waited in the Andorra waiting station (now Bruno's). (Germantown Historical Society.)

In the doorway of 43 Bethlehem Pike, built in 1876, is Elizabeth M. Goodwin on the left, widow of William, who lived here until 1912. Marion McKitten is on the right. The man is Mrs. Goodwin's half-brother Richard Broades. An Acme food market replaced this house, probably in the 1930s. The Acme was demolished in 1972 to make way for the Top of the Hill retail development.

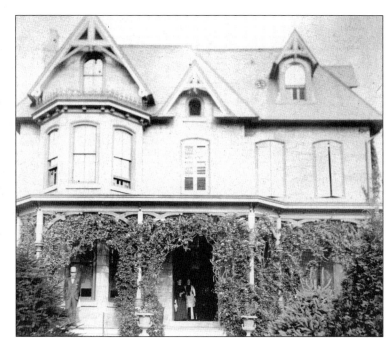

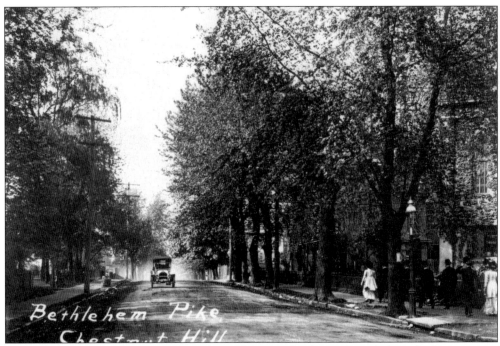

This view looks north along unpaved Bethlehem Pike beyond its fork with Germantown Avenue c. 1910. To the right is the Chestnut Hill Baptist Church, covered with ivy. Barely visible through the trees is a stucco Italianate-style house (also pictured below), where the Sunoco station is today. In the 19th century, Germantown Avenue was much more residential than it is today. This property once encompassed the present Sunoco lot and eight adjacent houses on the south side of Summit Street. Developer Samuel Austin acquired the property in 1854 and widened a 12-foot-wide lane to 50 feet, calling it Summit Street. This house was demolished c. 1933 to build the gas station. (Above, Germantown Historical Society.)

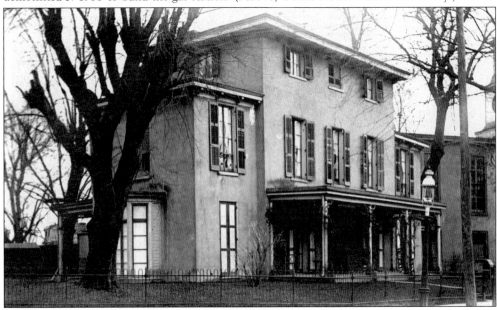

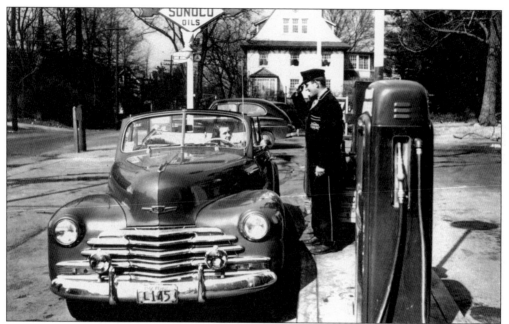

Deborah Melcher posed for this Sunoco Company publicity shot in her fiancé's new 1947 Chevrolet convertible at the top of the hill along Bethlehem Pike. The station was a "training station" where employees of Sunoco came to learn the business from the bottom up. Morris Stout began working here in 1947 and soon went on to the real estate division of Sunoco. (Deborah and Morris Stout.)

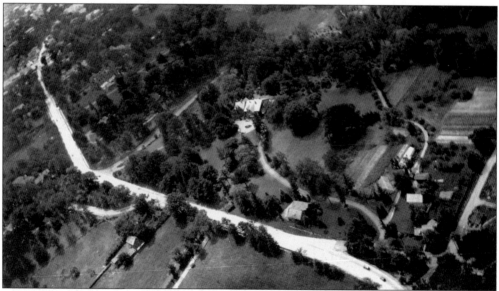

Flying solo above his house, Joseph Van Sciver Jr. took this photograph of Bethlehem Pike leading toward Chestnut Hill c. 1930. Paper Mill Road is the thin straight lane in the lower center. Stenton Avenue curves in from the left to intersect the much wider Bethlehem Pike. Joseph's house, Ingleside (see page 69), is in the center. The mansion on the left is Lynnewood Hall (see page 66), with its loop road, now Lynnebrook Lane. This intersection was changed in 1968.

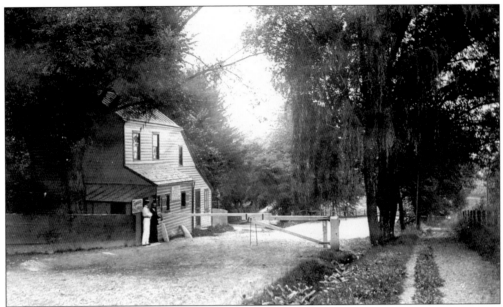

This was the tollhouse at the intersection of Bethlehem Pike and Stenton Avenue c. 1900. Stenton Avenue is visible in the center distance. Bethlehem Pike curves to the right toward Erdenheim. Bethlehem Pike was a toll road from the early 19th century to 1904. The tollgate is down in this photograph. It stood just in front of the Van Sciver barns, above Bells Mill Road. (Joseph C. Thomas Jr.)

This 1929 view looks south along Bethlehem Pike as it climbs Chestnut Hill from Erdenheim. Intersecting the pike in the foreground are the vestiges of the trolley tracks that ran down Hillcrest Avenue to the Erdenheim amusement park, White City, and returned along Hillcrest back toward downtown Philadelphia. The overhead trolley wires have been removed. The yellow bricks used to pave the track bed are on the left. Shortly after this photograph was taken, Bethlehem Pike was widened.

Two
TRAINS AND TROLLEYS

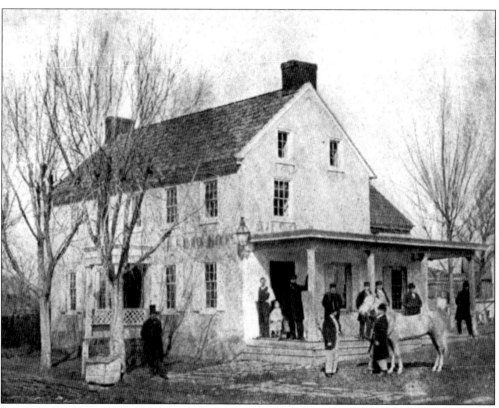

In 1854, the Chestnut Hill Railroad (later the Philadelphia & Reading Railroad) became the first railroad to reach Chestnut Hill. Pictured is the Railroad Hotel, on Bethlehem Pike next to the depot at New (now Newton) Street in the 1860s. It became a hotel for coachmen, who lodged their horses in the stable behind. Richard Magee, with his hand on the column, was the proprietor. In the late 1880s, the Reading Railroad bought and demolished the hotel to build a roundhouse for steam engines.

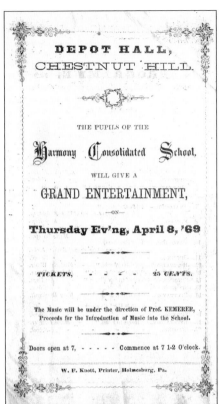

The Chestnut Hill Railroad's first depot building on Bethlehem Pike was a modest wood structure of which no photograph remains. Depots in smaller towns were sometimes built with a large room for community gatherings. Pictured is a program printed in 1869 for a performance at Depot Hall by the pupils of the Harmony Consolidated School, located up Bethlehem Pike from the depot. Founded in 1794, it was the first school in Chestnut Hill. (Stephen Corson.)

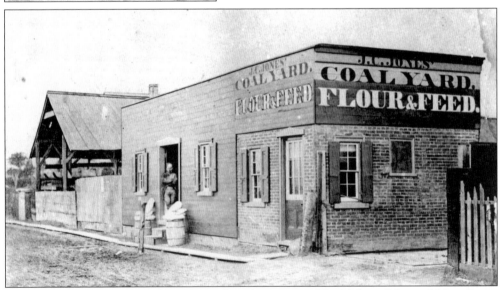

Jeremiah C. Jones's coal yard was located at the corner of Bethlehem Pike and New Street before 1875. Coal yards were typically located near railroad stations, where coal cars were unloaded. In 1875, Edward Dwyer bought the Jones's coal yard. He built a house across the tracks from the coal yard at 124 East Chestnut Hill Avenue in 1885. Five generations of Dwyers have worked at the company, now called Walter A. Dwyer Inc. Fuel Oil in Ambler. (Dwyer family.)

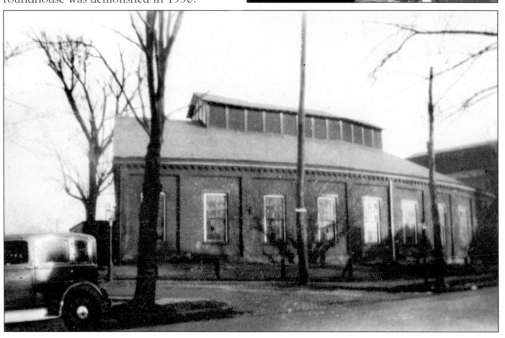

In 1870, the Chestnut Hill Railroad was leased to the Philadelphia & Reading Railroad, which built this turntable and roundhouse at the end of the line in the late 1880s for servicing steam engines. The two bars at the edge of the turntable were used to turn the locomotive manually. The tank supplied water for locomotives' steam. Below is a photograph of the roundhouse at the corner of Bethlehem Pike (foreground) and New Street. This photograph was taken after the Reading line was electrified, shortly before the roundhouse was demolished in 1930.

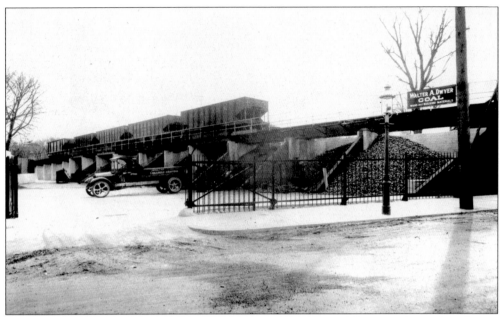

Railroad cars brought coal to Chestnut Hill, where it was poured from an elevated track into these "coal pockets" beside the Reading Railroad terminus depot. The Dwyer's White Motorcar Company truck, dating from *c.* 1915, delivered building materials as well as coal. In 1938, at age 14, Walter T. Dwyer's son William Dwyer practiced driving this truck around the yard. (Dwyer family.)

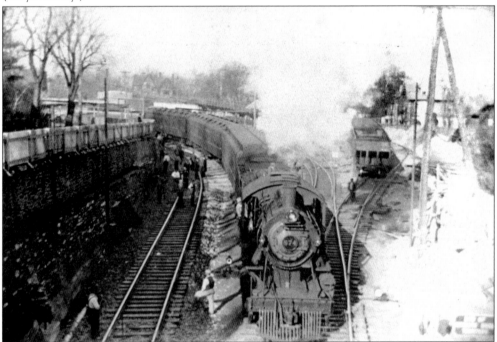

A steam train travels near what is now the Chestnut Hill East station *c.* 1929. The engineer leans out of the cab to look toward the Summit Street bridge, on which the photographer is standing. (Dwyer family.)

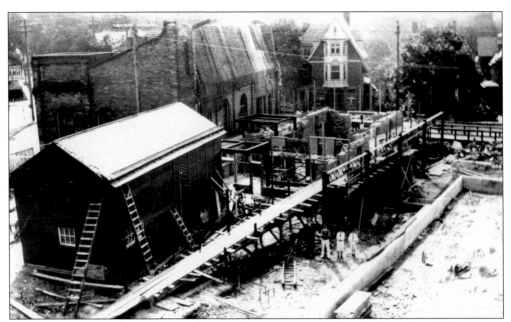

In 1930, the Philadelphia & Reading Railroad electrified and modernized its lines. The 1872 depot, on the left, is shown half demolished while the present depot (1931) is being built. Charles Stewart and three Dwyer boys stand in the foreground. Behind them is a ramp on which masons pushed wheelbarrows loaded with mortar to erect the stone walls. At the bottom right, the concrete platform of the rail bed has already been poured. (Dwyer family.)

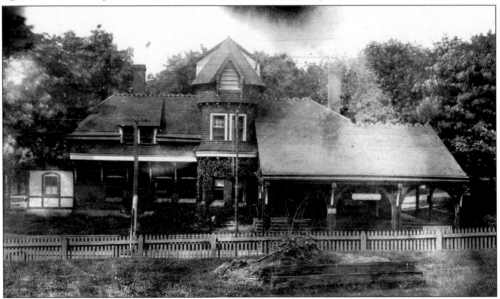

Frank Furness designed the Gravers Lane station in 1883. The Reading Railroad hired Furness in 1879 to be its official architect and to develop a corporate image that would reflect its influence and power. Many of the railroad stations designed by Furness are marked by the integration of the building roof with the shelter for passengers. The roof plummets down in a continuous line to form the porch roof. By 1907, a small frame addition had been added on the south side. (Robert Skaler.)

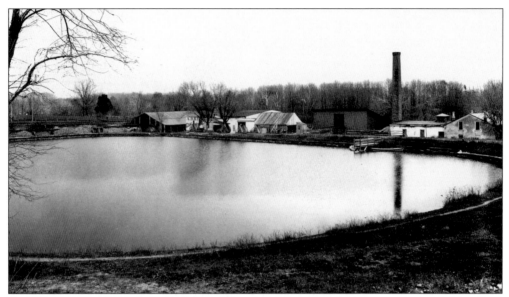

The Water Tower Recreation Center stands today where these buildings once stood. This view from 1896 looks east toward the Reading Railroad line. This was the Chestnut Hill Waterworks, which included a pumping station, a maintenance yard, and possibly the house of the waterworks manager. The water came from natural springs and a well. The "A. B. Kerper Coal" sign indicates a coal yard operating here, too. In 1874, the city took over the waterworks. (City of Philadelphia Water Department.)

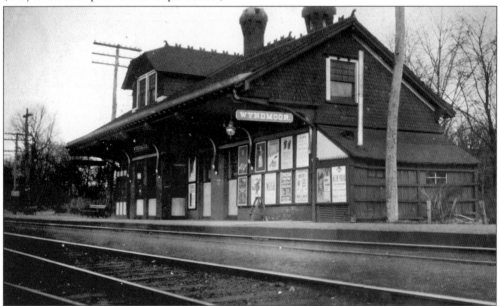

Pictured here in 1917, the Wyndmoor station of the Philadelphia & Reading Railroad was built in 1884 from Frank Furness plans by Tourison Brothers. In 1884, the *Germantown Independent* newspaper announced the name of the station would be changed from the Indian name Tedyscung to Wyndmoor. This station stood on the southeast corner of the intersection of the tracks with East Willow Grove Avenue. A stationmaster's family often occupied much of the space in railroad stations. (Philadelphia City Archives.)

A railroad employee with a flag stands at the grade crossing by the Wyndmoor station in 1898. The 1929 photograph below looks west along East Willow Grove Avenue toward the grade crossing of the Philadelphia & Reading Railroad Railroad tracks. The Wyndmoor station is out of view on the left. The crossing guard's shanty, usually heated by a coal-fired stove, is adjacent to the tracks on the right. Before the train arrived, the crossing guard would lower the gates visible here to protect people and carriages approaching the tracks. (Germantown Historical Society, Philadelphia City Archives.)

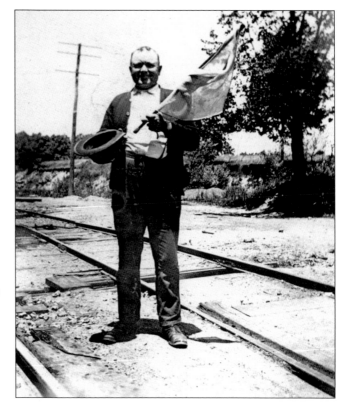

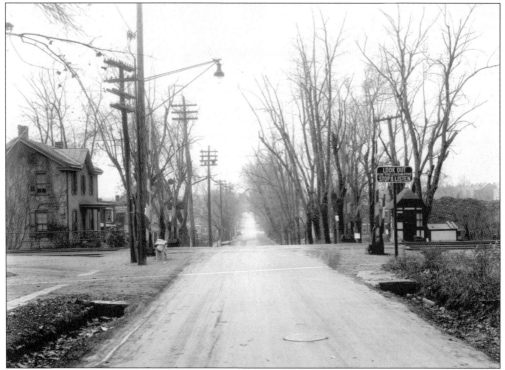

The 1929 photograph above shows the one-block-long Wyndmoor Avenue along the railroad tracks before the grade crossing at East Willow Grove Avenue was removed. Railroad tracks split off from the main line here to serve a coal yard. In 1930, the federal Work Projects Administration (WPA) funded the elevation of the railroad tracks and the construction of a new Wyndmoor station. The former station had to be demolished because it was lower than the new level of the tracks. Below is the same view a year later, after construction was completed. The house on the right at 230 East Willow Grove Avenue is visible in both views. (Philadelphia City Archives.)

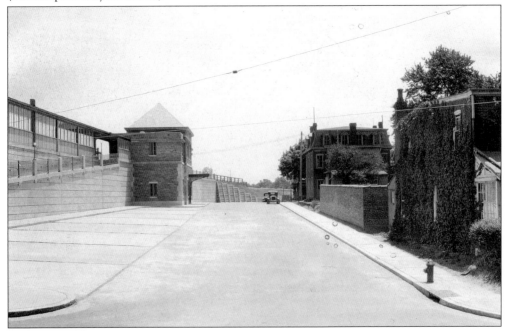

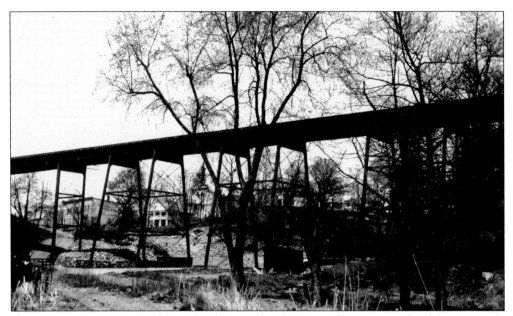

The iron viaduct over Cresheim Creek opened in 1884 to allow a second rail line to reach Chestnut Hill. This was the Philadelphia, Germantown, and Chestnut Hill Railroad, a subsidiary of the Pennsylvania Railroad. In this 1912 photograph, Cresheim Road is in the foreground; Cresheim Valley Drive had not yet been opened. The building with the flat roof was probably a row of three mill worker's houses, demolished for the extension of Lincoln Drive. The viaduct was replaced in 1988. (Germantown Historical Society.)

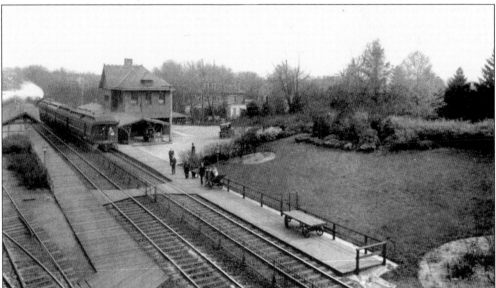

The Pennsylvania Railroad's first stop in Chestnut Hill is St. Martin's station, originally called Wissahickon Heights, pictured in 1914. W. Bleddyn Powell was the architect for the station, opened in 1884. The station agent who lived and worked here typically sold tickets, supervised freight, received telegraph messages, and so on. Freight trains used the sidings on the left to deliver and receive products such as blocks of ice before the days of refrigeration. (Chestnut Hill Academy.)

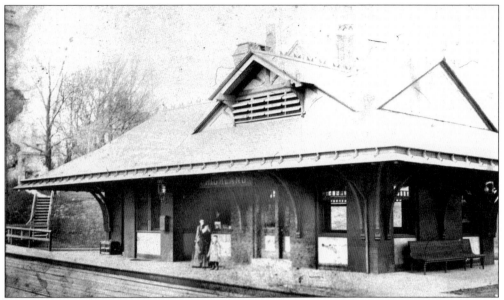

In 1884, passenger trains made 18 round trips a day between downtown Philadelphia and Chestnut Hill on the Pennsylvania Railroad. Shown is the one-story inbound depot at the Highland station c. 1900. Across the tracks was the larger, two-story outbound station. This woman and child are waiting for the train to take them toward Philadelphia. Both buildings were demolished c. 1916 so that the new Highland Avenue bridge could be built over the tracks.

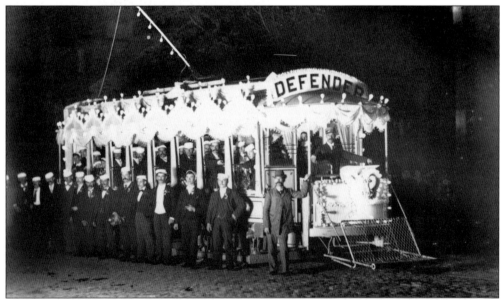

In 1895, the People's Passenger Railway Company was the first electric streetcar line to reach Chestnut Hill. In 1896, this party streetcar, painted white and pink, is on the way back from Chestnut Hill Amusement Park (also called White City) in Erdenheim. It has stopped in front of 8617 Germantown Avenue. The company rented trolleys to groups to develop business. The ban on alcohol was often ignored, and carousing got too loud for the neighbors, resulting in the elimination of party cars by 1900. (Andrew Maginnis.)

A Philadelphia Rapid Transit (PRT) conductor, left, and a motorman pause on the Route 23 trolley at the Mermaid loop in 1939. In the front top of the car, a line through the number indicates the car is a "cut back" car, routed around the Mermaid Trolley waiting station below for the return trip to Philadelphia and skipping the trip to the top of the hill. As ridership was denser below Chestnut Hill, not every trolley went to the top of Chestnut Hill. Route 23 went from south Philadelphia to Chestnut Hill, the longest trolley route in the city. The PRT built the Mermaid station in 1910 at Germantown Avenue and Cresheim Valley Road. In 1947, a substation was built beside the Mermaid Lane building to provide additional power. (Below, Andrew Maginnis.)

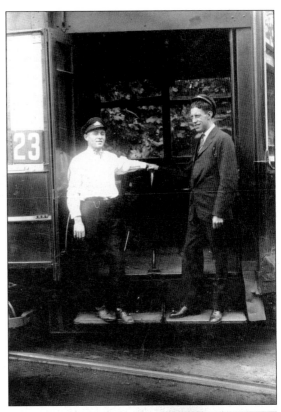

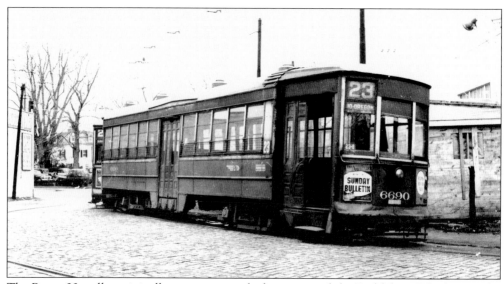

The Route 23 trolley originally went counterclockwise around the Bethlehem Pike loop at the top of the hill. The direction was reversed in 1978 because traffic made the left turn difficult. In 1947, this trolley was photographed behind the Gulf station, with the Acme store fronting on Bethlehem Pike on the left. In 1920, the PRT built a battery powerhouse here to replace the former Union Traction Company powerhouse at 8100 Germantown Avenue, now a day-care center. (Karl P. Then.)

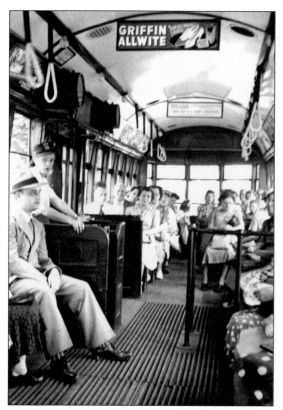

Here is a typical crowd on the Route 23 trolley c. 1943. What is unusual is the female conductor in the booth on the left. During World War II, women were hired to take the place of the men who left for military service. Before automobiles were common, a spiderweb of regional trolley lines served southeastern Pennsylvania. Although railroad lines served Chestnut Hill, the trolleys provided a cheaper alternative. (Andrew Maginnis.)

Three

VISIONARY
DEVELOPMENT

After the first railroad line reached Chestnut Hill in 1854, the village remained a largely undeveloped farming and milling community, with much open space. This stereo view of Paper Mill Road in the 1870s gives an idea of what much of Chestnut Hill looked like not far from busy Germantown Avenue. The view looks west toward Stenton Avenue. At the dip in the road is the stream that runs near present-day Montgomery Avenue. (Raymond Holstein.)

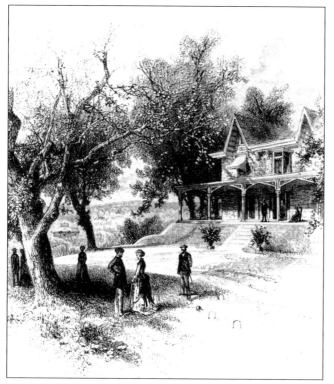

Charles Taylor was one of the first to see Chestnut Hill as an ideal place to build homes for Philadelphia's wealthy families. In 1849, he built Norwood, a Gothic-style cottage with a view of the Whitemarsh Valley, at 8891 Germantown Avenue. This romantic view of country living shows a woman in her rocker on the porch and a woman in a dress with a train playing croquet with others. There is no hint of crops and livestock, which would have been a common sight in much of Chestnut Hill in the 1870s. Below is the same house some 30 years later. Even in the early 20th century, Springfield Township, visible in the distance, still had much open space. (Above, Germantown Historical Society.)

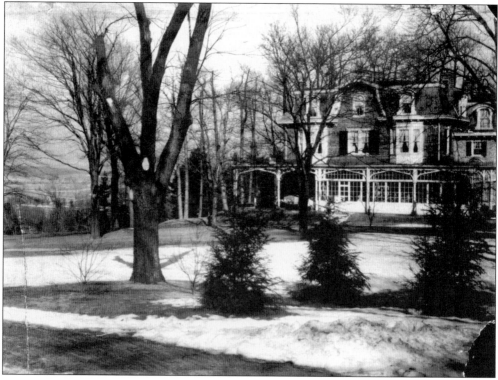

In 1854, Samuel Austin opened Summit Street to sell property to "summer sojourners," as the locals called them. Many of the new houses in Chestnut Hill were designed with summer living in mind, with their large porches and observation towers. Businessmen who lived in Philadelphia townhouses used their Chestnut Hill residence as a second home. Families were thought to benefit from the healthful atmosphere. This is 100 Summit Street in 1899. (Germantown Historical Society.)

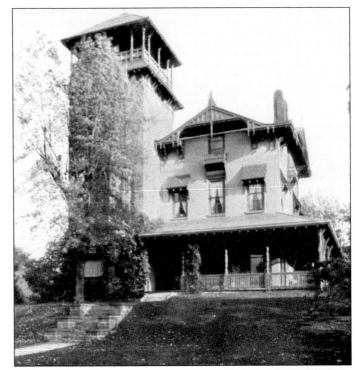

Constructed in 1857, the house at 26 Summit Street was one of three houses built by Daniel Brady on this street. In 1906, the blocky third story and bay window were added. Later, the house was so greatly modified with the removal of the porch and the addition of a high-peaked roof that the building is virtually unrecognizable today.

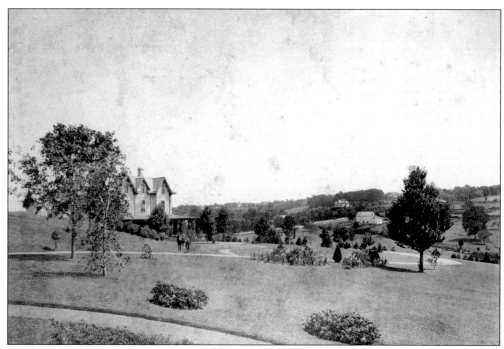

In 1875, a serpentine drive winds through the garden of Wyncliffe, home of Joseph Page, now on a property now called Sugarloaf. This view shows a rural Chestnut Hill, with a large barn and pastures contrasting with the stylish new homes of the wealthy. The barn vanished c. 1887. The distant house, owned by Alfred Harrison, is at Germantown and Sunset Avenues. In the middle distance on the right side, Bell's Mill Road descends toward the Wissahickon Creek.

Henry Houston was once the largest single landholder in Philadelphia. He developed over 200 houses in northwest Philadelphia along the Pennsylvania Railroad line. In 1885, Houston commissioned George W. and William D. Hewitt to design this block of twin houses on the 8300 block of Shawnee Street, photographed in 1912 from across Donat's field. Dr. George Woodward purchased this field c. 1915, created Pastorius Park, and donated it to the city.

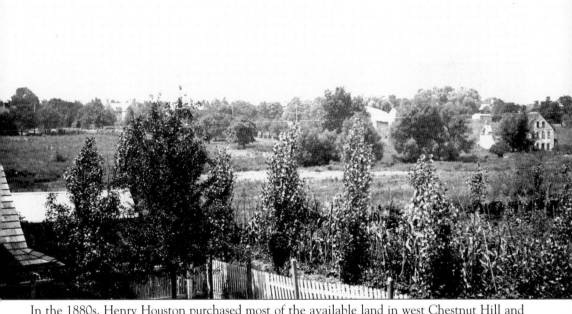

In the 1880s, Henry Houston purchased most of the available land in west Chestnut Hill and opened 30th and 31st Streets, which became Seminole Avenue and St. Martins Lane. In 1914, the photographer of this view stood in the backyard of 59 West Willow Grove Avenue, with the roof of 8001 Crefeld Street, visible on the left, looking northwest toward the Kerper farm, on the right. The farm is now Pastorius Park. The rooftops and chimneys among the trees are the backs of 8035, 8037, and 8133 Seminole Avenue. In 1899, Pennsylvania Railroad executive George Rogers built the house at 8133 and called it Wissahickon Heights. Navajo Street had not yet been opened behind these houses.

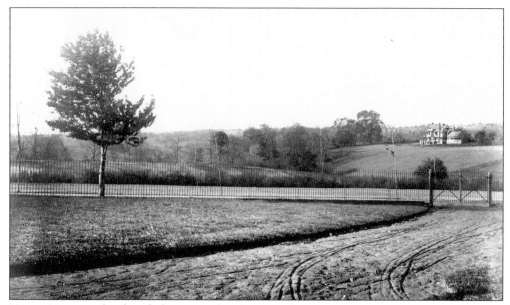

Henry Houston developed the east side of Seminole Avenue between Rex and Highland Avenues c. 1886. There were still fields across the street, seen here with Rex Avenue sloping toward the Wissahickon Creek, in the center. In 1884–1885, Wilson Eyre Jr. designed the house in the distance, at 444 West Chestnut Hill Avenue. By 1895, a total of 53 of the 60 houses Houston built were rented. Houston screened, rented, and sold houses to white, Protestant, well-to-do people.

"Mr. H. H. Houston's pretty stone cottages" was how chronicler S. F. Hotchkin described this house and its neighbor in 1889. G. W. and W. D. Hewitt designed these two houses on West Chestnut Hill Avenue in 1884–1885. In the 1920s, Richard Austin had one house raised on blocks and used horses to move it several yards east to join to 422 West Chestnut Hill Avenue. The resulting single dwelling was a wedding present for his daughter. (Robert Skaler.)

Gladys West surveys a rural scene along the 200 block of West Springfield Avenue c. 1910, with the icehouse behind her and the fence on the right surrounding an ice pond. In 1886, Henry Houston developed the houses at 300, 302, 306, and 308 West Springfield Avenue, on the left. Since the Pennsylvania Railroad tracks for the west line were still on grade level, there is no bridge over Springfield Avenue as there is now.

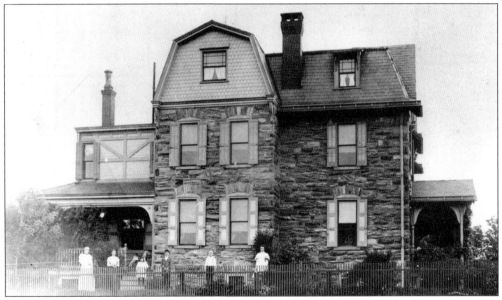

This family stands in the side yard of 230 West Willow Grove Avenue in the 1890s. The little girl's rocking horse is behind her. Not all new housing was developed by Henry Houston. In 1887, Edward Casey, who owned an ice business, hired Ashton Tourison, a Mount Airy homebuilder since the 1870s, to build this twin house. This photograph was taken from the empty lot where 225–228 West Willow Grove Avenue was to be built by Casey's son James.

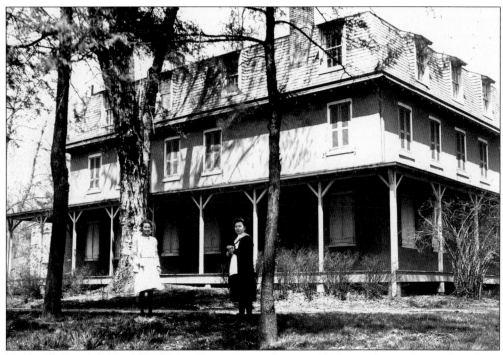

Henry Houston donated Buttercup Cottage, seen here c. 1912, as a home for single, white, working women to live in the summer, far from the heat of the city. A farmhouse, it stood along what is now Cresheim Valley Drive. Gertrude Houston Woodward was president of the all-female board of managers, which included socially prominent women. An Episcopal nun, Sister Ruth, supervised. The cottage accommodated up to 22 boarders, who were asked to contribute what they could. (Germantown Historical Society.)

After Henry Houston died in 1895, his daughter Gertrude and her husband, Dr. George Woodward, carried on his legacy of molding Chestnut Hill into an ideal community. Starting in 1904, they commissioned nearly 200 houses, striving for high-quality design and workmanship. They changed the name of the west side of Chestnut Hill from Wissahickon Heights to St. Martin's in 1906. In 1913, they moved into Krisheim, whose south facade is shown clad in wisteria.

The neglected 1828 Union Burying Ground, north of West Gravers Lane at Millman Street, did not fit into George Woodward's vision for the area. It is pictured *c.* 1915 with 8342 Millman Street behind it. Woodward purchased the land and had the bodies, including some Civil War soldiers, reburied. In an attempt to rid Chestnut Hill of a backward look, he had many dilapidated older houses removed, thus eliminating some of the early fabric of the community. (Germantown Historical Society.)

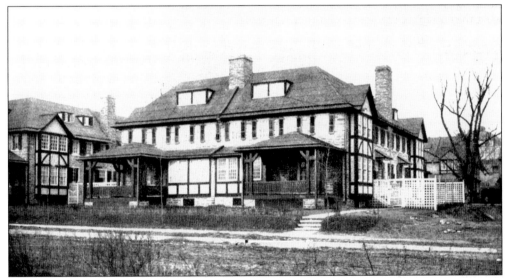

Duhring, Okie, and Ziegler designed these "quadruple houses" (back-to-back double houses) for George Woodward. The houses are between Benezet Street and Springfield Avenue. In a 1913 article, Woodward wrote, "The quadruple house is a logical development of the semi-detached or twin house . . . [it] appears as one large dignified dwelling house with thirty feet of lawn in the front and it is only on closer inspection he discovers that one roof covers four families." (Athenaeum of Philadelphia.)

51

This building at 7801 Lincoln Drive, said to be an 18th-century barn, was converted into an icehouse. Its ice pond was where Lincoln Drive is now. H. Louis Duhring, who did most of the adaptive reuse of buildings for George Woodward, renovated the icehouse into a residence in 1908. Lincoln Drive was newly extended, following the path of a streambed. (Free Library of Philadelphia.)

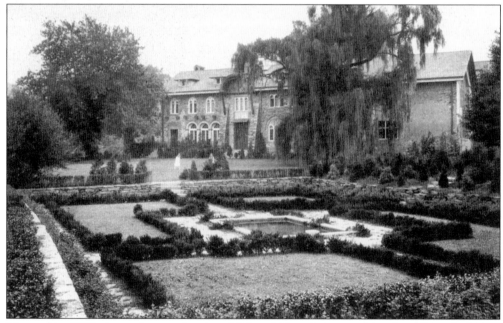

Pictured in 1916, the garden on the site of Edward Casey's ice pond bordered Lincoln Drive. The Woodwards included a garden plan for each dwelling. George Woodward renovated the former icehouse into a studio for Willet Stained Glass Studios in 1913. Elizabeth Serianni remembered "Willet's park" as a destination for picnics when she was a child in the 1920s, noting that inevitably someone would drop a shoe in the pool. (Athenaeum of Philadelphia.)

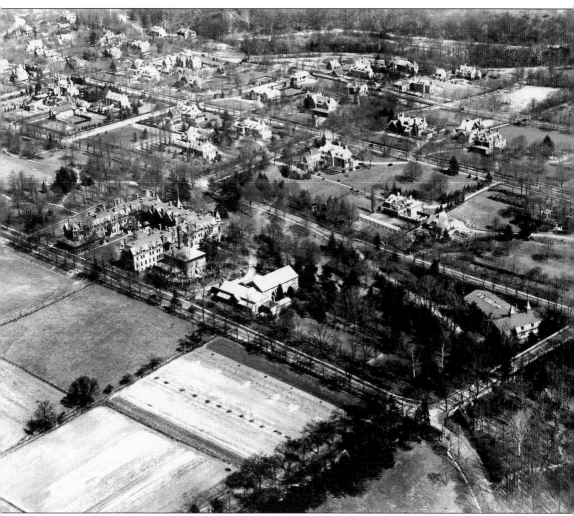

This 1927 aerial view shows the many substantial estates that Henry Houston and, later, Gertrude and George Woodward helped create in what came to be known as St. Martin's. The fields in the foreground are now the athletic fields of Chestnut Hill Academy, whose buildings are across Willow Grove Avenue from the fields. To the left is St. Martin's Green, a park where the school track is located today. (Free Library of Philadelphia.)

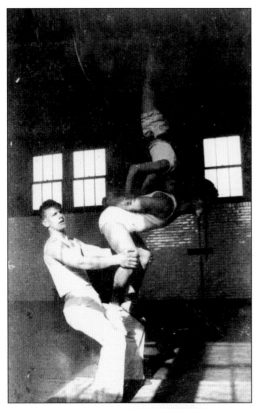

The Woodwards created the Henry H. Houston Woodward Water Tower Recreation Center in memory of their son, who died in World War I. Here, in 1937, Bruno Colussi does a headstand on top of Caesar Massaro, with friend Leo as support. Young men from Chestnut Hill competed on the rings, parallel bars, tumbling, and the like. Seen below are the May queen and her reluctant-looking court at the May Day celebration of 1926. They are seated behind the recreation center before two wings were added. Children danced around a Maypole and played games. From left to right are Caesar Massaro, Mary Murray, Jennie Massaro, Dorothy Barton and her brother, Anne Morasco, and Mary Dunlevy, who became a sister at St. Joseph's Convent in Chestnut Hill. Mary Murray's Irish immigrant father was a chauffeur for Wilson Potter, who lived at Anglecot (see page 100). (Cheryl Massaro.)

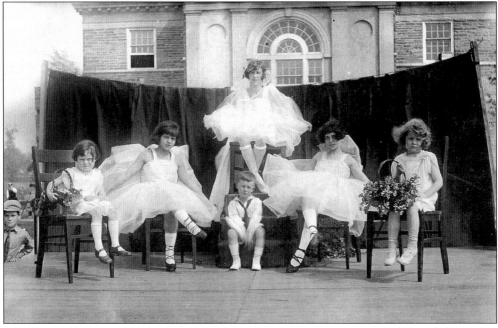

Four

PROSPERITY
AND PRIVILEGE

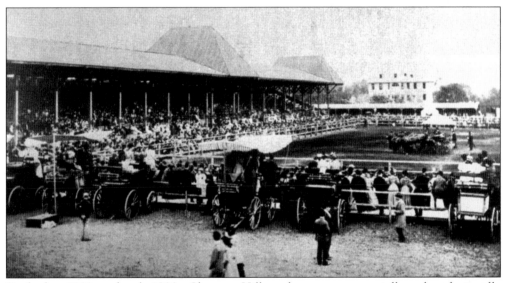

By the late 1920s and early 1930s, Chestnut Hill was home to more socially and professionally prominent residents than any single community in the Philadelphia area. The affluent upper class kept apart from other social groups, seldom crossing paths with less privileged citizens except as employers, as store customers, and sometimes as church members. From 1892 to 1908, a gathering place for the social elite was the Philadelphia Horse Show, which took place next to the Wissahickon Inn along Willow Grove Avenue. In the background is the first of two clubhouses designed by Theophilus Chandler in 1892. This one was replaced with a two-story clubhouse in 1905, presumably after a fire. It was located where the Philadelphia Cricket Club pool building is today. A magazine reported that the Philadelphia Horse Show was "aided by fashion and Society with a capital S."

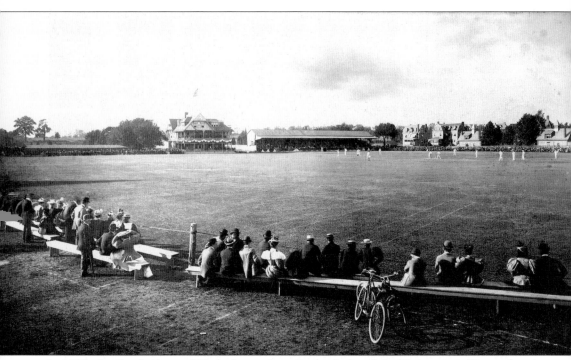

In 1895, the Cambridge and Oxford team from England played the University of Pennsylvania team at the Philadelphia Cricket Club, sometimes called Wissahickon. The larger building is the original clubhouse, completed in 1886. On the right are houses and carriage houses from the 8000 block of St. Martins Lane. In the foreground are the lines on the grass for tennis courts. Wealthy Chestnut Hillers, often of English descent, tended to follow British social and leisure customs such as playing cricket. Today, it is difficult to imagine how avidly Philadelphians followed cricket, with newspapers posting hourly bulletins of the scores of international matches. In 1927, the Cricket Club held its last cricket match of that era.

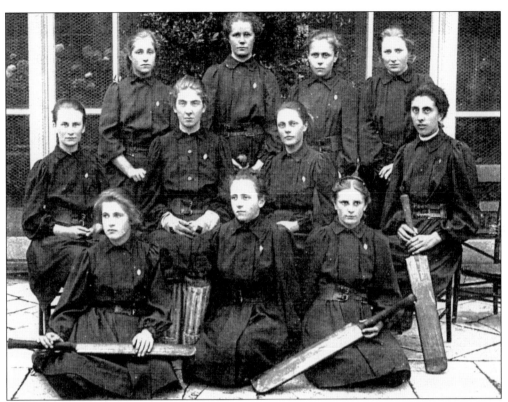

This women's cricket team photograph, taken *c*. 1900, was found in the collection of the Philadelphia Cricket Club, but no information has yet been found about women playing cricket at the club. The women hold cricket bats and wear uniforms of short dresses, bloomers, and thick leather belts.

Beginning in 1896, women members of the Philadelphia Cricket Club could enjoy their own clubhouse, pictured *c*. 1908. Women could socialize, change clothes, or partake of refreshments as long as they were nonalcoholic and served in a proper single-gender setting. Staff members, who often lived at the club, waited on the women. This building, originally designed by Kennedy, Hays, and Kelsey, was restyled in 1911 to match the Georgian Revival look of the new main clubhouse. Its eyebrow dormers remained.

The Philadelphia Cricket Club with the newly built clubhouse is shown *c.* 1910, complete with cupola, which was said to have been modeled after Independence Hall. The first Junior Clubhouse, built in 1899, is on the right. It burned in 1927. Squash courts designed by Robert McGoodwin were built on the site later that year. The large canvas suspended between two poles on the cricket field was a screen erected as needed behind the wickets and the bowler (the pitcher) to block out background interference for the batsman.

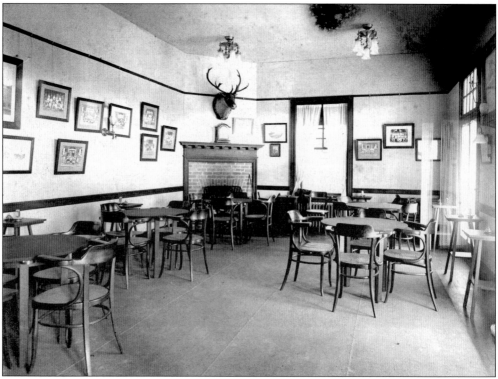

The card room at the Philadelphia Cricket Club, now the bar, is shown *c.* 1915, with team pictures and a stag's head displayed on the walls.

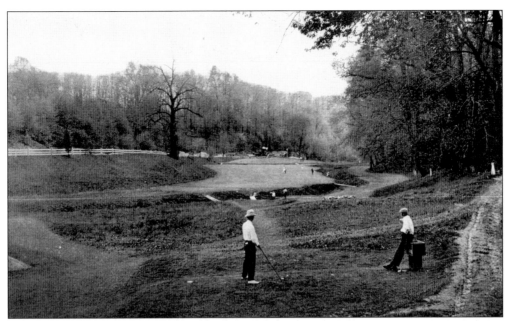

This view looking toward the Wissahickon Creek in 1909 shows the eighth hole of the St. Martins golf course, a part of the course that was built in 1895. In 1898, nine more holes were added. The first Philadelphia Golf Association Open was played at the Philadelphia Cricket Club in 1903.

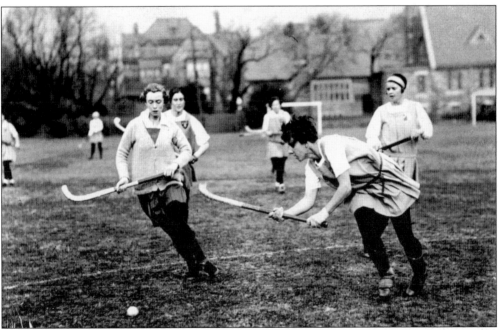

The Philadelphia Cricket Club was a center for field hockey, newly introduced to America from England. In this c. 1929 view, a Philadelphia team plays an opponent at the club, with the Church of St. Martin-in-the-Fields in the background. Hockey was so popular at the time that each of the three major Philadelphia newspapers had a female reporter who wrote about hockey every week.

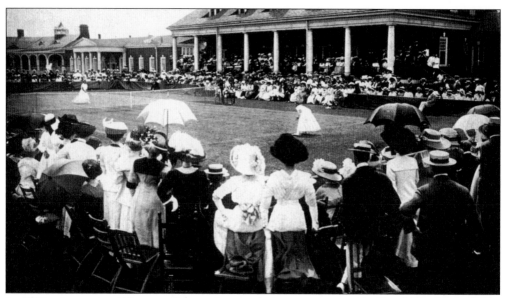

In 1911, spectators with parasols crowd around the court to watch Hazel Hotchkiss defeat Florence Sutton in front of the Philadelphia Cricket Club.

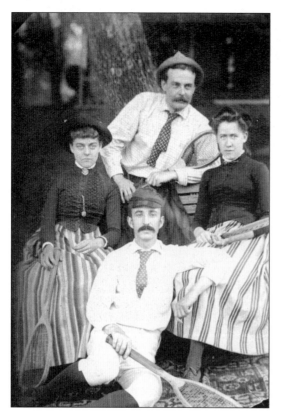

Wyle T. Wilson, a student, and his friends pose c. 1882 with tennis racquets. Wilson lived on Summit Street in the 1890s. Tennis and golf became popular, edging out slower-paced cricket as the games of choice for affluent Chestnut Hillers. These sports allowed men and women to participate together and did not require 11 people to form a team. A decade after this photograph was taken, the Philadelphia Cricket Club began hosting the National Mixed Doubles championships.

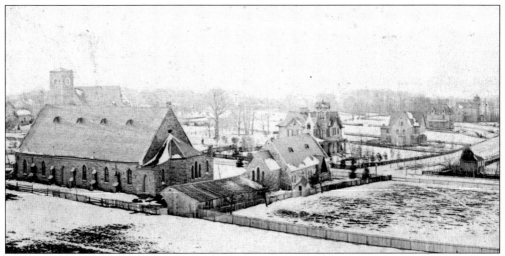

The wealthy residents of Chestnut Hill were predominantly Episcopalian, and their numbers were sufficient to support two churches. Above is an 1870s view of St. Paul's Episcopal Church with the original chapel, built in 1856. The church on the left, built in 1864, was replaced with a larger sanctuary in 1929. Warming sheds for horses are between the two buildings. Our Mother of Consolation Church, then St. Mary's, is visible in the distance, as are houses along Norwood Avenue.

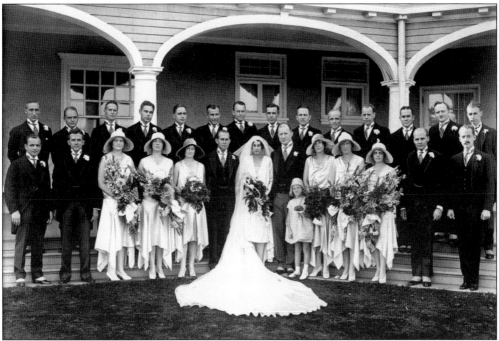

The wedding party for Bertha and Fred Graham poses outside the Women's Clubhouse of the Philadelphia Cricket Club after the ceremony at St. Paul's Church in 1929. Fred Graham had grown up at 2 Summit Street, down the block from Bertha Smythe, at 100 Summit. He opened a Philadelphia brokerage firm, which became highly successful in the booming 1920s. The stock market crash cut short the Grahams' Bermuda honeymoon and altered the course of his career. (Avery Tatnall.)

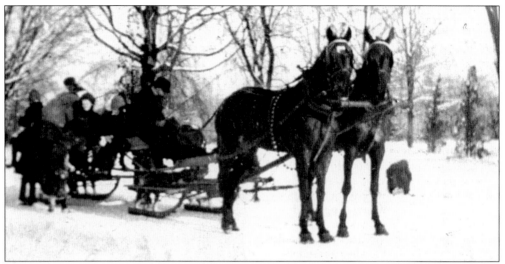

Wealthy Chestnut Hillers often maintained fine teams of horses and fancy carriages. Sleighing was popular, as in this *c.* 1910 scene of a "hitching party." Nora Taylor, who grew up in the early 20th century in Chestnut Hill, remembered standing in the road with her sled, waiting for a sleigh to come by so that she could ask the driver for a hitch. If the driver said yes, she would loop the sled rope around a runner and then go skimming over the roads.

In 1879, sisters Jane Bell and Anna Bell Comegys recognized the need for a girls' school to serve the burgeoning elite population. They founded the French and English Boarding and Day School for Young Ladies and Little Girls, later called Springside School. Some day students who "wintered'" in the city enrolled for the first and last two months of the school year. In 1890, the founders built 41 East Chestnut Hill Avenue beside the school, pictured in 1907. (Christopher Lane.)

The rural life of Chestnut Hill was seen as healthy, as well as spiritually and morally beneficial. The founders of Springside were brought up with the same class and cultural standards as their clientele. In 1905, the tuition for Springside was more than the annual salary of two-thirds of working men in the United States. Participating in team sports was a new idea for upper-class girls at the end of the Victorian era. In the early 20th century, Springside girls played basketball. In 1934, students participated in the elaborate May Day celebration shown below at the junior school at the corner of West Willow Grove and Seminole Avenues. The May queen was Barbara Newhall. On horseback is Lois Jordan, with Josephine Harmar holding a mandolin and Juliana Meryweather on the far right. During the Depression years, Springside's books were filled with accounts in arrears because many families no longer had enough money for tuition. (Springside School.)

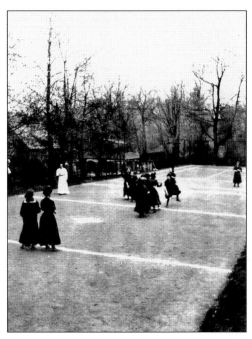

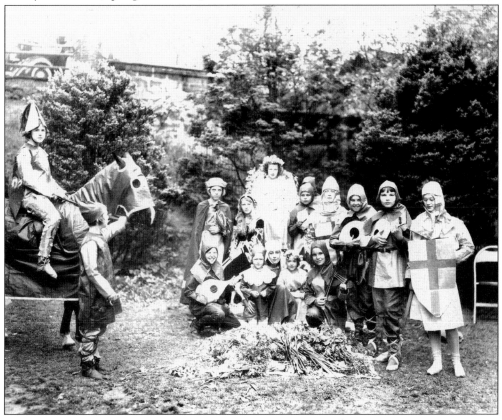

In 1919, Miss Catherina Zara's School for the primary grades was started in the parish house of St. Paul's Church. In 1933, the school moved to 516 West Moreland Avenue. It competed for enrollment with Springside School during the Depression. By 1948, there were 145 students enrolled. Miss Zara's merged with Springside in 1954, and this building was demolished. As early as 1896, the Wissahickon Heights School and Kindergarten, later called Miss Landstreet's School, was located at 312 West Moreland Avenue.

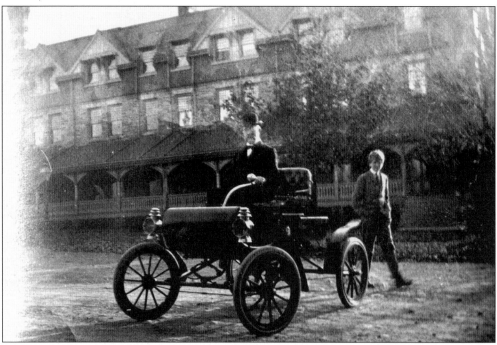

Headmaster James Patterson holds the tiller of his 1904 Oldsmobile in front of Chestnut Hill Academy. With its front shaped like a toboggan, the car had two kerosene brass lamps and could reach 25 miles per hour. The school shared the building with the Wissahickon Inn for two years until the inn closed in 1900. The affluent in Chestnut Hill wanted their children to be well educated but also wanted them to mix mostly with others of their own class.

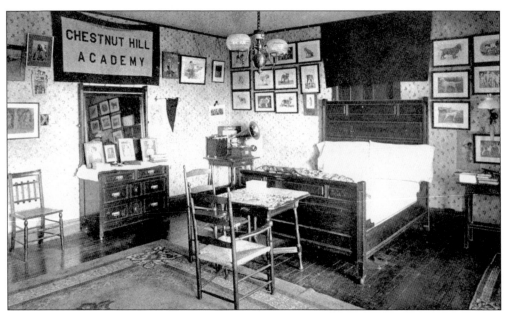

The 1914 Chestnut Hill Academy prospectus advertised the school's boarding program and showed a boy's room, complete with pennants, phonograph, and dog photographs. Boarding students were automatically junior members of the Philadelphia Cricket Club. In the school's early years, the youngest boys accepted were 11 years old. Chestnut Hill Academy was enhanced when the Philadelphia Horse Show moved to Devon and the Houston estate provided some of that land for athletic fields. (Chestnut Hill Academy.)

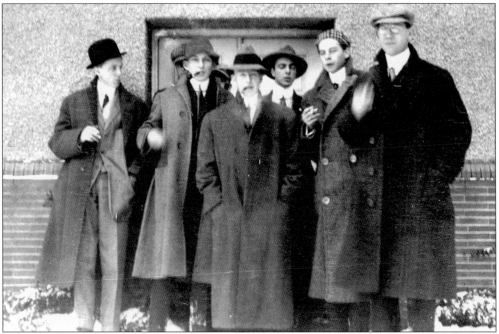

This photograph is labeled "gang at the smoking hole, 1911." The students are standing behind Chestnut Hill Academy's swimming pool building at Willow Grove Avenue. This building, now the Commons, was constructed in 1905. (Chestnut Hill Academy.)

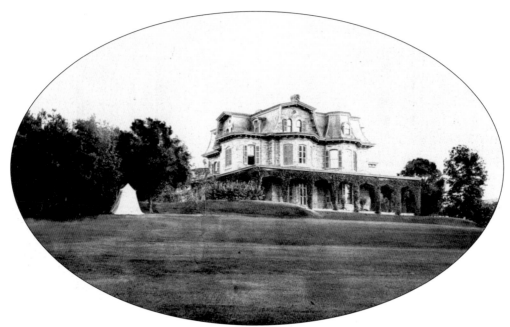

Banker Edwin N. Benson had a summer house at 155 Bethlehem Pike, shown above *c.* 1870. It burned in October 1883, and Benson replaced it with a much bigger mansion, Lynnewood Hall, whose colossal porch is visible below. Sisters-in-law Mildred Benson Packard and Ethel Weightman Benson pose on the private tennis court in 1909. As a boy in the 1930s, William Dwyer remembered calling Lynnewood Hall "the castle." The Bensons allowed him and his friends to play football on the lawn. The house, which was used only as a summer residence, had no central heating. It was demolished in 1940 and the property was subdivided. (Below, Richard Snowden.)

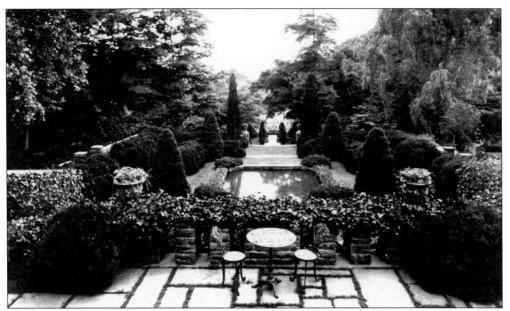

Druim Moir, built in 1885–1886 as the home of Henry Houston, overlooked terraced gardens, pictured *c.* 1921. The estate "was run like a little town," with 22 people working on the grounds. Among them were four men in the greenhouse, a cow man, four gardeners, and a chauffeur living in the gatehouse. Below, a man at Druim Moir tends the incubators, which hatched as many as 10,000 chickens a year. All the poultry and eggs produced were just for the use of the extended Houston family at Druim Moir and the surrounding estates. Ignatius Galante, who also worked at Druim Moir, took eggs daily to the "big house," where the Houston family lived with 11 servants. Galante had been in the military in Italy and saw World War I looming. He immigrated to Chestnut Hill with his family in 1914.

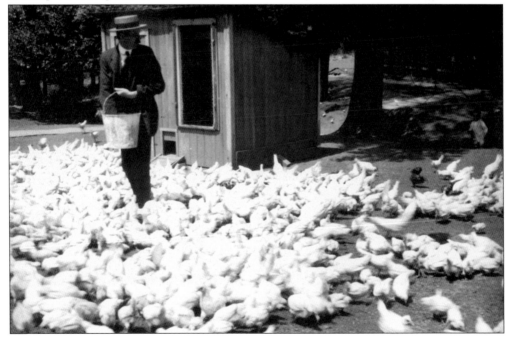

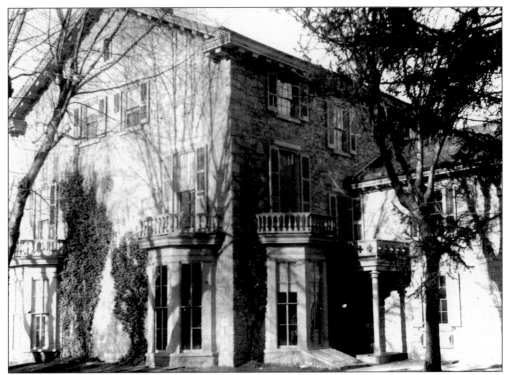

Joseph Bishop Van Sciver, successful sand and furniture merchant from Camden, decamped to fashionable Chestnut Hill c. 1897 after he made his fortune. He rented his first house, called Edge Hill, between Bells Mill Road and Sunset Avenue. Built in 1853, it is now Assumption Hall at Norwood-Fontbonne Academy. Orphaned at age 10, Van Sciver was raised by two aunts. He converted the aunts' sweet potato farm into a sand business and learned the upholstery trade. Below is Edge Hill's fantastic Moroccan-inspired interior in 1898, rich with textiles, indicating that Van Sciver was at the forefront of fashion. (Above, Joseph B. Van Sciver III.)

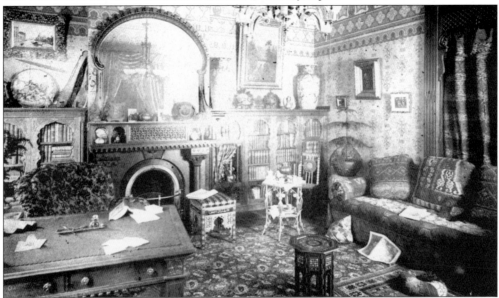

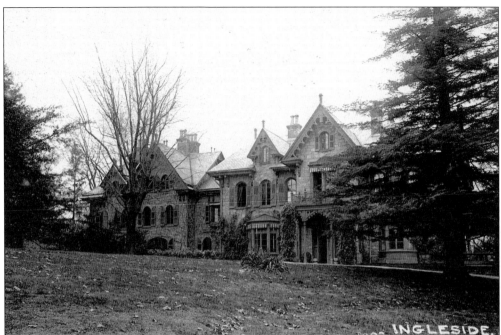

INGLESIDE.

Joseph and Flora Kelly Van Sciver left Edge Hill *c.* 1906 for 8864 Germantown Avenue. After 1907, they rented and later bought John Bohlen's mansion, Ingleside, at 195 Bethlehem Pike, pictured here. In 1929, Van Sciver sold his sand business before the stock market crash and invested in bonds, preserving his wealth. He took a trip around the world. In the photograph to the right, they are aboard the royal elephant as guests of the Maharajah of Jaipur, India. (Joseph B. Van Sciver III, Mary Van Sciver Biddle.)

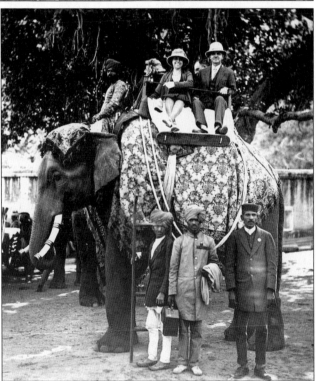

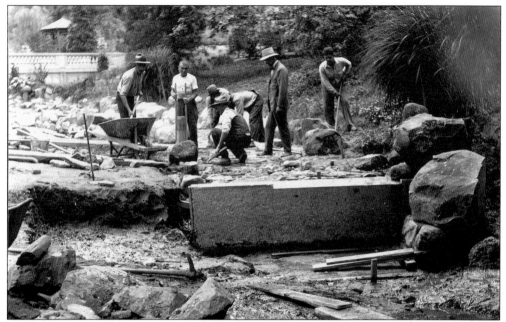

In the 1930s, Joseph Van Sciver was able to indulge his passion for gardening on his 20-acre property. He employed seven gardeners to realize his vision. If he saw a rock with an interesting shape in a farmer's field, he would stop and offer to buy it. Pictured in 1930, his workers are constructing a pond and streambed. Below is the finished project, with a limestone balustrade bridge designed by J. Linerd Conarroe. By 1943, taxes were too high for Joseph Van Sciver Jr. to maintain the house and gardens. He demolished the house and built a smaller one on the foundations, and the gardens gradually became meadows. (Joseph B. Van Sciver III.)

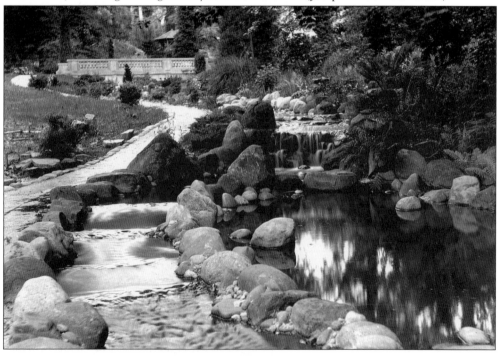

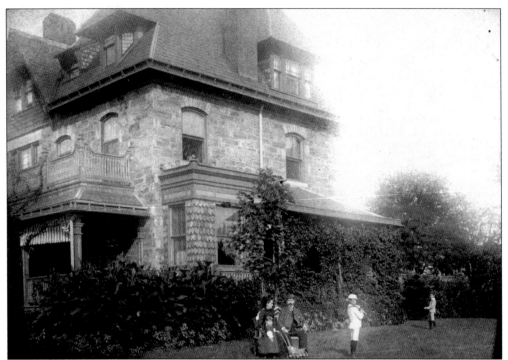

Henry Bell Jr. plays baseball in his yard with his friend Julian Tingley c. 1892. Martha Bell lays her doll in a fancy miniature stroller. Tingley lived across the railroad tracks from the Bells, at 8635 Seminole Avenue. Children of prosperous entrepreneurs, such as shoe manufacturer Henry Bell, lived among and went to school with children from extraordinarily wealthy families. Comfortable and elegant, the Bell house was modest compared with the mansions of the wealthiest in Chestnut Hill. (Linda Stanley.)

In 1905, Rosalie Cook Carpenter pauses with her daughter Virginia at 14 Summit Street, built between 1862 and 1871. The Carpenters lived here from 1905 to 1961. Virginia's father, Joseph Carpenter, was a banker who took the train to work downtown. He won the first National Mixed Doubles Tennis championship with Hazel Hotchkiss at Forest Hills, New York, in 1909. Virginia Carpenter won the Girl's National championship in doubles for three years running with three different partners, and toured Europe playing field hockey.

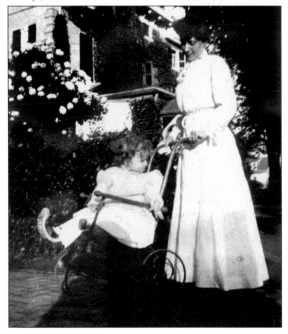

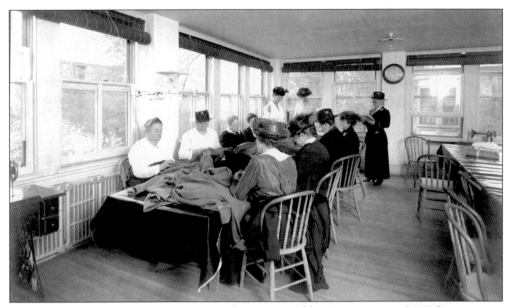

National League of Women's Service members repair soldiers' overcoats at 8419 Germantown Avenue. These well-to-do women left their sheltered world to support American soldiers and refugees during World War I and to aid the disadvantaged in the city. The "Service House" had a tearoom with patriotic posters and slogans, including "Women's League For God, For Country, For Home." They held a luncheon for drafted soldiers, whose car was decorated with "Look out, Kaiser Bill, here comes Chestnut Hill." They taught Italian girls to sew for children in Italy. The volunteers, "many of whom had never before grasped the inside peculiarities of a chicken," made meals during the influenza epidemic of 1918. After the war, their headquarters became the Chestnut Hill Community Centre. Below, c. 1920–1924, volunteers sell produce near the top of the hill, working for local farmers.

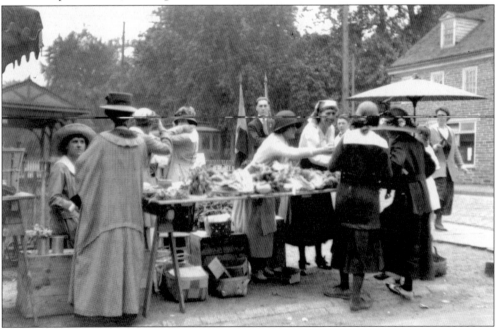

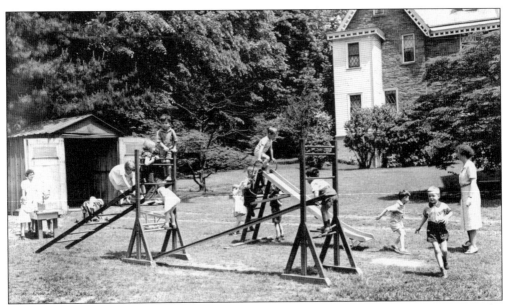

Clarissa Smythe Melcher, pictured in 1938, grew up comfortably in Chestnut Hill. During the Depression, her husband, William Melcher, lost his job. His brother-in-law offered him a job, but money was tight. To help out, Clarissa opened the Play School in 1933, recognizing that families who could no longer afford live-in help needed someone to watch their children. The school later moved to the Presbyterian church, the former parsonage of which is in the background here, now the Chestnut Hill Historical Society.

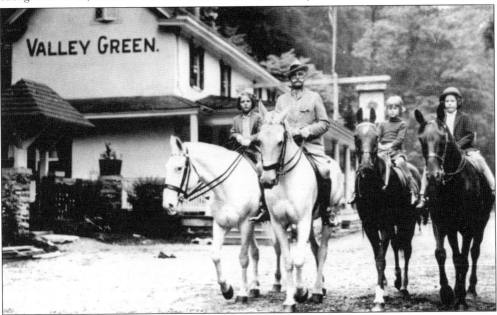

Captain Demling, formerly of the U.S. Cavalry, lived at 230 Rex Avenue and kept a large stable of horses. Here, he rides past the Valley Green Inn in 1937 with his neighbor Patsy Steward (Walsh), second from the right. Patsy Steward kept her horse at the Port Royal Stables in Roxborough and had a glorious time riding around the Wissahickon Valley. Her father, head of a brokerage firm when the stock market crashed, saw his way of life change forever.

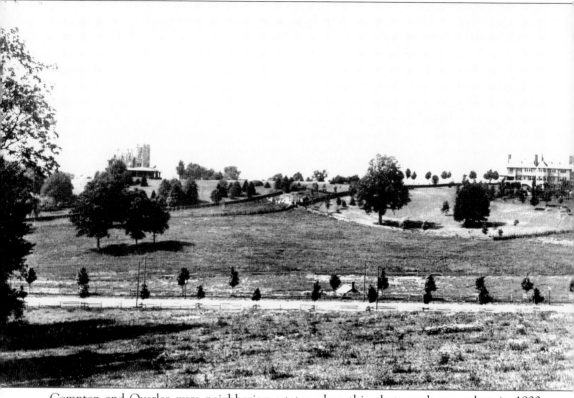

Compton and Overlea were neighboring estates when this photograph was taken in 1900. Hillcrest Avenue is in the foreground, with newly erected overhead trolley wires. The pastures here give little hint of the meticulously planned gardens, just beginning to be developed by siblings Lydia and John Morris, that would become the Morris Arboretum. The Orange Balustrade, newly built, is near the center of the photograph, just below the ridge. The fence line below the big tree in the center is where the Oak Allee is now located. At this time, John Lowber Welsh owned the land on either side of Hillcrest. The springhouse complex in the foreground was used to store and cool milk. The entrance to Compton was from Meadowbrook Avenue, along the top of the ridge, through impressive gates, which are still there today. (Morris Arboretum.)

Five
WORKING FAMILIES

Archibald Lawson worked as a gardener and lived on Henry Houston's estate, Druim Moir, c. 1890. In 1891, Lawson moved to 54 West Willow Grove Avenue and set up the Wissahickon Heights Nurseries, building this greenhouse in 1896. In 1910, the Lawsons sold the corner portion of the property at Crefeld Street to Dr. George Woodward, who built the twin houses at 56 and 58 West Willow Grove Avenue and 7913 and 7915 Crefeld Street.

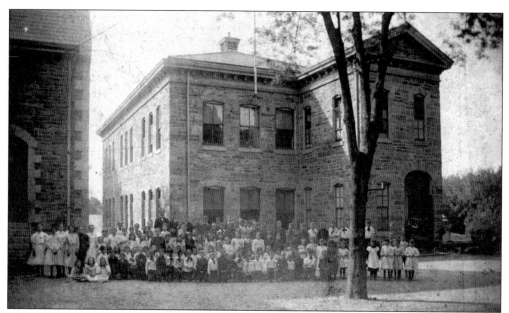

The first school building at Our Mother of Consolation Church, pictured here in the 1890s, was built in 1887. The school, called St. Mary's Lady of Consolation when founded in 1855, was largely attended by Irish Catholics. Many of the first parishioners were from Ireland, emigrating after the famine of 1847. When a new building was dedicated in 1916, there was a parade featuring "William Spillane, 14 years old, dressed as Uncle Sam and Mary Reilly, costumed to represent Columbia."

Elizabeth Huston came in 1899 to West Philadelphia from Ireland to work as a maid. In 1916, she purchased this store at 8616 Germantown Avenue and operated there until 1960. She spoke with a thick Irish brogue and sold fabric, yarn, notions, clothes, maid's uniforms, white gloves for dancing class, toys, and other items. She enlarged the E. Y. Huston Store, remodeled four apartments above it, and eventually bought the building next door, installing catwalks in between. (Lela H. Kerr.)

Many Irish who immigrated to Chestnut Hill relied on relatives already settled here to aid them in America. Women typically served as domestic servants, getting up at 5:00 a.m. to do cooking, cleaning, washing, and ironing. They often worked until 7:30 p.m. and had Thursday and Sunday afternoons off. Many Irish men worked as coachmen-gardeners. These unidentified Irish maids worked at the Van Sciver family home, Edge Hill, c. 1903. Their three young charges are Lloyd, Russell, and Joseph Jr. Van Sciver, riding their toy wagon, modified into a car with a horn, funnel, and bicycle lamp. In the picture below, the Van Sciver women's dresses are more ornate and fashionable. From left to right are Albert Kelly, his sister Flora Van Sciver, an unidentified man, and Mary Van Sciver, with Joseph Jr. in front. (Joseph B. Van Sciver III.)

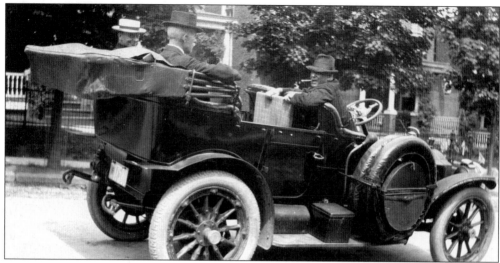

Patrick O'Neil was born in Dublin, Ireland. In 1890, O'Neil and his wife, Margaret, built a house at 230 Benezet Street. He was a coachman who, with the advent of automobiles, turned chauffeur, working for multimillionaire Edmund Waterman Dwight at the sprawling estate called Sunset. O'Neil is pictured c. 1909–1914 driving Edmund Dwight's Packard on Ardleigh Street. Tragedy struck the O'Neil family when Margaret died of influenza in 1918 and Patrick died two years later. (Ellen O'Neil Maher.)

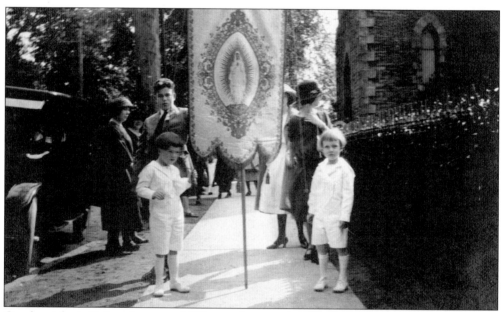

On the right is Robert Lester c. 1920, standing on the sidewalk in front of Our Mother of Consolation Church with a May procession banner. Lester's father of the same name was born in Germantown to an Irish Protestant blacksmith father and an Irish Catholic immigrant mother, Sarah Welsh, who was a housekeeper. Young Lester came to live with the Kolbs, his other grandparents, on Northwestern Avenue after his father died of influenza in the epidemic of 1918. (Barbara Woodling.)

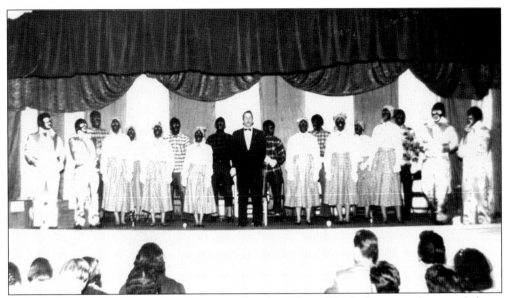

Beginning in 1890, members of St. Mary's Church performed Irish dramas and minstrel shows in an era when few could afford a trip to downtown Philadelphia for a performance. Minstrel shows with white actors impersonating grossly caricatured African Americans, considered offensive today, were a popular form of entertainment. Many churches in the area, into the 1940s, held minstrel shows as fund-raisers. Here, William Dwyer, center, sings with actors in stereotypical costumes and blackface. (William Dwyer.)

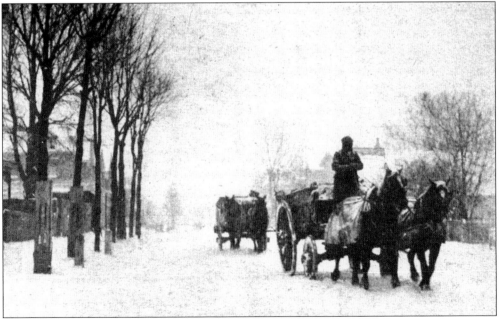

By 1900, coal furnaces were heating most houses in Chestnut Hill. Dwyer coal company workers would dump the coal from a wagon, and later trucks, into a coal chute leading from outside a house down to the basement. In late summer, the Price house, at 129 Bethlehem Pike, received one load for the house and another for the greenhouse to keep the roses warm. In this view, looking east along Evergreen Avenue, the loaded wagon is trailed by a second one.

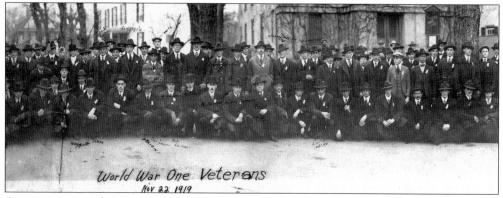

World War One Veterans
Nov 22 1919

A newspaper article in 1919 read, "Will Honor War Heroes, Chestnut Hill Dines Living and Unveils Memorial for Dead." Shown here is a portion of a panoramic photograph of World War I veterans who assembled in front of the Baptist church and attended a dinner in their honor. The veterans and citizens marched down Germantown Avenue to the site of a cross of stone bearing the names of the 19 soldiers from Chestnut Hill killed in the war. The memorial was a gift from the Woodwards, whose son was killed in France.

Antonio Roman immigrated from Poffabro, Italy, to work. He returned to Italy in 1915 to bring back his bride, Vittoria, shown here with daughter Lucy. The Romans settled here, at 1003 Pleasant Avenue in Wyndmoor, which became a haven for immigrating cousins including Oliver Marcolina, shown c. 1923 with paintbrush and pail, helping to pay his keep until he was launched in the area. During the Depression, work was so scarce that Roman sent his family back to Italy. (Rosie Roman Rosa.)

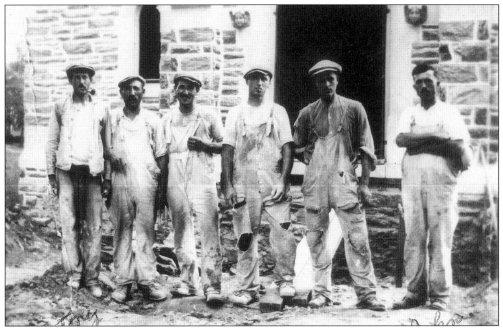

On the left is Antonio Roman, and on the right is John Conti, a contractor from Chestnut Hill, with coworkers at a job site. Both men worked as masons building the majestic Bryn Athyn Cathedral probably *c.* 1918. After World War I, Roman began his own company on Roanoke Street and, later, at 7942 Germantown Avenue. In 1922, he built the Roanoke Garage at 31 West Willow Grove Avenue, adorned with its name in decorative brick. (Rosie Roman Rosa.)

Many of the stonemasons of Chestnut Hill came from Poffabro, Italy, which had a tradition of migrant stoneworkers who often traveled to Germany for work. Joseph Marcolina, right, was sent to Germany at age 12 with his brother to learn to cut stone. Augostino Tramontina (playing the accordion) came to the Colorado silver mines in 1900 before coming to Chestnut Hill. This late-1920s photograph was taken in the yard of the Cosano home, at 7634 Ardleigh Street. (Helen Marcolina Henry.)

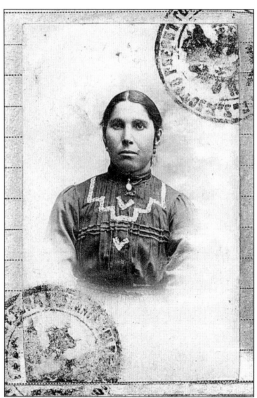

Domenica Staffieri, shown in her 1920 passport photograph, came to America from Abruzzo, Italy. Her husband, Pasquale Staffieri, had come to Chestnut Hill earlier, after serving in the Italian army. The Staffieris raised four children at 211 Benezet Street, a block where practically every house had either an Italian or Irish family. Like many Italians in Chestnut Hill, the Staffieris "lived from the earth." Pasquale grafted pear trees in his backyard and produced three varieties of pears on a single tree. (Anne Marie Staffieri.)

Friends Sante Filippi and Albert Marcolina came from Poffabro, Italy, in 1921. They built this house at 8037–8039 Roanoke Street in 1926 and drew straws to see who would occupy the south side. Filippi worked as a stonemason for seven years before bringing his family over. Shown in 1938 are Filippi and his wife, Maria, top. At the lower right is son Louis, beside a friend, with his brother, Tony, behind him, and sister Judy at the right. The brothers started a welding business that became Filippi Iron Works. (Judy Filippi McLaughlin.)

This wedding photograph was taken in Poffabro, Italy, in January 1929, when John Giacomelli returned to marry Maria Rosa. When Maria joined Giacomelli at 8008 Roanoke Street a year later, she did not speak any English. In the first decades of Italian immigration to Chestnut Hill, many Italian couples married at the Holy Rosary Church in Germantown. Our Mother of Consolation in Chestnut Hill was closer, but Holy Rosary served mainly the Italian community. (Dolores Giacomelli Barrosse.)

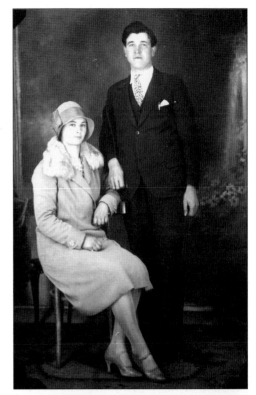

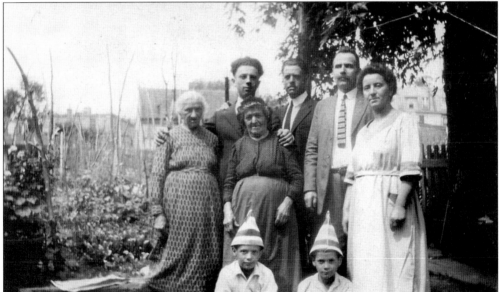

In the 1890s, Oswaldo Massaro came from Mani, Italy, to New York, returning to his homeland to bring over his bride, 14-year-old Italia Toffalo, right. The Massaros moved to Chestnut Hill in 1917. Pictured in 1924 are Massaro's mother, Maria, left, with her grandchildren Joe and Caesar in the family garden at 8116 Devon Street. Italia Massaro kept pet crows, which she raised from fledglings. Oswaldo Massaro, a terrazzo setter, died after eating a poison mushroom from the Wissahickon Valley. (Cheryl Massaro.)

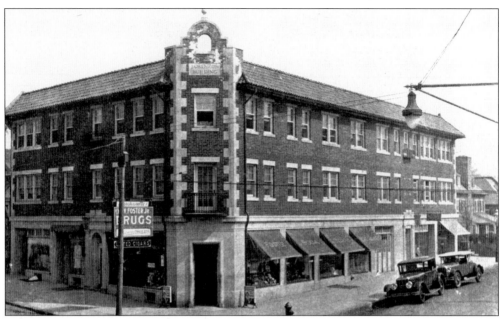

Five Lorenzon brothers—Charles, Augustine, Emilio, Vittorio, and Alberto—came to Chestnut Hill over a 10-year period beginning in 1896. Their father, Vincenzo Lorenzon, had trained them as skilled stonemasons. The Italian economy weakened *c.* 1900, causing many to immigrate. Some 200 families moved to Chestnut Hill from Poffabro, leaving that Italian village with half its former population. H. Louis Duhring was the architect of the Lorenzon Building at Germantown and Willow Grove Avenues, built in 1925. (Lorenzon family.)

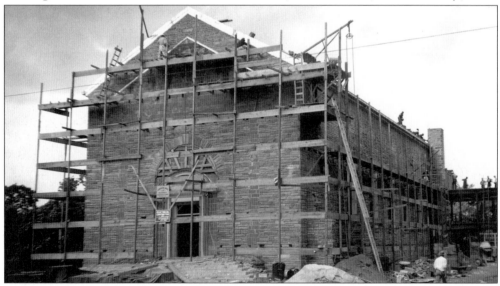

Construction of the Presbyterian church's new sanctuary began in 1948. The Lorenzon brothers, who were members of the church, were the masonry subcontractors. Their father, who had had a dispute with the Catholic church in Poffabro, Italy, converted when Protestant missionaries visited his village. The Lorenzon brothers quarried the stone on site as they excavated the basement. They were primarily stonemasons until the 1950s, when Herbert took over from his father, Emil, and entered the general contracting business. (Lorenzon family.)

In 1926, Emil Lorenzon built this house for his family at 7827 Ardleigh Street. His widowed mother, Maria Roman Lorenzon, and his son, Herbert, are pictured here *c.* 1930 in the lush produce garden the mother tended in front of the house. In 1932, the city took away the garden and opened Springfield Avenue by the Lorenzon house, seen below with Emil's Chrysler parked at the curb. Emil Lorenzon told his family that they were Americans now and that everybody should speak English, except to his mother. (Lorenzon family.)

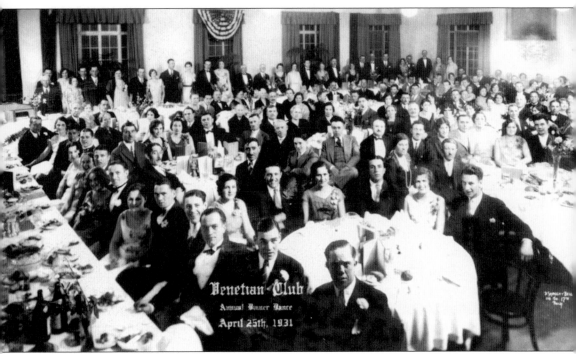

Venetian Club
Annual Dinner Dance
April 25th, 1931

Shown is a dinner at the Venetian Club, at 8030 Germantown Avenue, in 1931. Many men from Poffabro, Italy, became club members and enjoyed cards, bocce, and socializing. Since children also attended social events, there was no need for babysitters. During World War II, federal officials investigated the Venetian and Bocce Clubs, looking for anti-American activity. Many Italian Americans got rid of their shortwave radios so as not to incur suspicion. As the Italian community in Chestnut Hill grew concerned that the U.S. government might deport Italians, some women began taking English classes. Until then, immigrant housewives had little incentive to learn English since their center of activity was the neighborhood. After Italia Marcolina took the course, she got assembly line work at the Yarnall-Waring machine works. She was heartbroken when she had to quit after servicemen returned. (Naomi Colussi Houseal.)

Southern Italian men had started the Chestnut Hill Bocce Athletic Club by 1926. In 1929, they acquired the clubhouse at 118–120 Hartwell Lane. Shown *c.* 1931 are Frankie Altomare (holding the measuring stick) and Tony D'Lauro (holding the trophy) with Dominic Brindisi and Sam Risotto. The all-male membership met to play cards and socialize. Original members were from Calabria and Sicily, Italy, but later members such as Bartolomeo Pio came from the Piedmont region. The club is active today. (Chestnut Hill Bocce Club.)

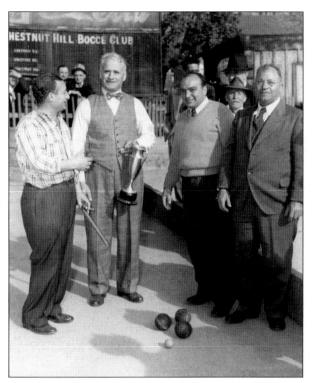

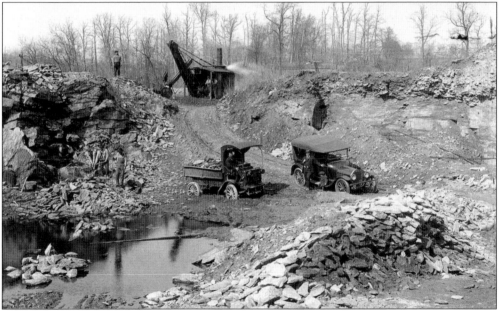

In the 1920s, Frank Comley and then Walter Dwyer owned this quarry, in the 200 block of East Willow Grove Avenue. Filippo Yanni, standing at the top left, was a dynamite expert. He immigrated from Calabria, Italy, in 1909 and learned about blasting by working on the railroad in Spokane, Washington. Chestnut Hill stone is relatively soft when quarried and hardens nicely when set. A vein of the stone runs under all of Chestnut Hill, ending just north of Northwestern Avenue. (Mike Yanni.)

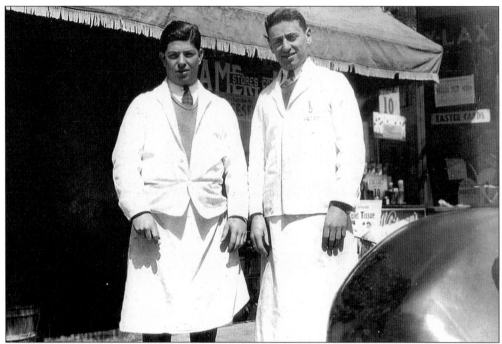

Born in 1911, Jimmy Longo, left, and Joseph Jacobi worked as clerks at this American Store (later Acme) in Erdenheim. Longo later worked at another store at 8144 Germantown Avenue. There was no self-service in those days. A clerk wrote down an order and crisscrossed the store to collect items, sometimes using a long pole to snag items up high. Longo's father came from Calabria, Italy, c. 1902 at age 20 and worked as a stonecutter in Chestnut Hill. (Jimmy Longo.)

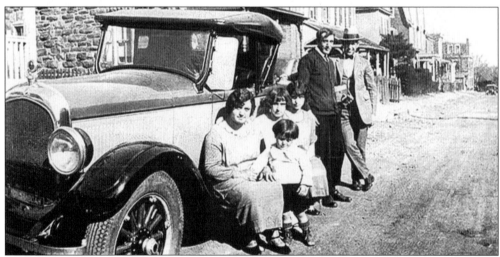

Pictured on Easter Sunday 1925 is the Morasco family on the 8100 block of Shawnee Street, which was still a dirt road. From left to right are siblings Rose, Vincent, Clara, and Frances Morasco. They grew up at 8143 Shawnee Street in a family of 11 children. Behind them are their uncles Achille Sirianni, a lamplighter in Chestnut Hill, and Sam Rosato. Another sister, Elizabeth, recalled that almost everybody on the block was related at this time. (Gerry Serianni.)

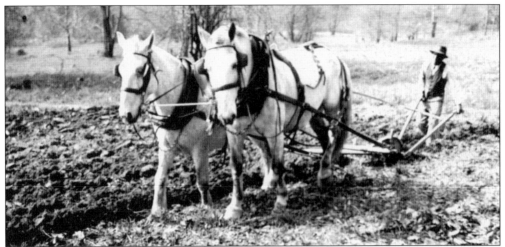

Daniel Pierson Nelson, born in 1898, was a milkman in Chestnut Hill. He took this photograph of Raffaele Casale plowing at Donat's field, owned by the Houston estate, along the second block of West Gravers Lane across the street from his house. He had an agreement with George Woodward—as many people did—to plant a garden there. The city had planned to continue Lincoln Drive through Donat's field and what is now Pastorius Park, arcing toward Germantown Avenue.

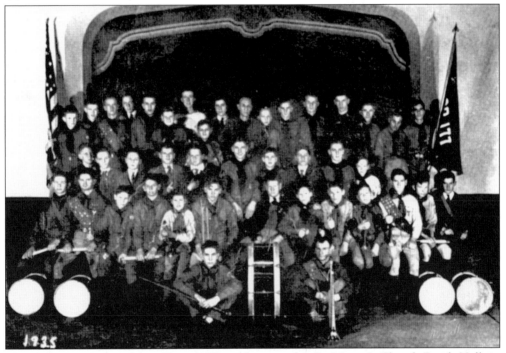

Founded in 1917, Boy Scout Troop 177 met here, at the St. Martin's Church Parish Hall, in 1935. In the back row, eighth from the right, is Scoutmaster Roger "Pop" Taylor. A favorite stop for children on Halloween was the Taylor house, on Winston Street, where cider and doughnuts were served. The troop hiked to city hall, where Taylor treated them to lunch at Wanamaker, a follow-up to lessons on table manners. Caesar Massaro is in the front, third from the right, and his brother Joseph is second from the left. (Cheryl Massaro.)

"Pio Wines" is lettered on the rooftop of this facility, located at Moreland Avenue and Winston Road. In 1948, Bartolomeo Pio took over the Glen Willow Ice Manufacturing building, where ice was made indoors in containers. The building converted nicely to accommodate Pio's redwood casks, shown below. Pio, seen in the back row between sons Elmo, left, and Albert, with daughter Linda seated third from the left, poses with employees. Generations of Pios had been winemakers in the Piedmont region of Italy. Bartolomeo Pio immigrated in 1906, and in 1923, he bought the Wheelpump Inn in Erdenheim. There, he ran a hardware store and sold seasonal produce including grapes. When Prohibition began in 1919, he started selling grapes from California for people to make their own wine. After Prohibition was repealed in 1933, he switched to selling wine under the Pio name. (Pio Wines.)

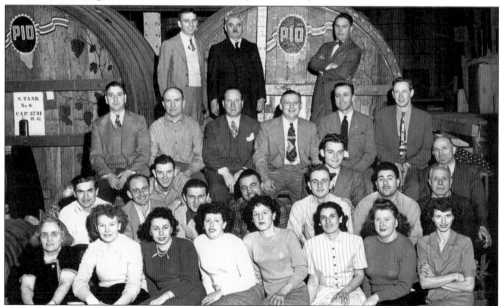

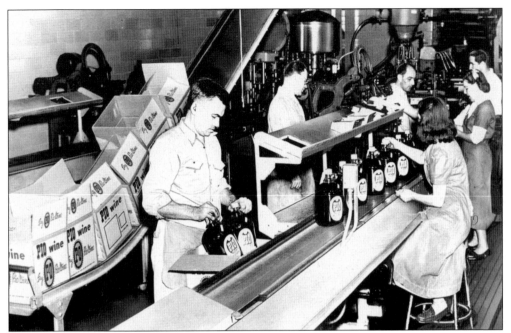

These workers could bottle 5,000 cases a day and then label and ship them. The founder's grandson has memories of sitting on a case of wine and going through the entire plant on this conveyor belt. Trains brought wine juice to Wyndmoor station, and trucks brought it from there to the plant. In 1950, Bartolomeo Pio bought a California winery. The family business continues today as a Gallo distributor and as an importer of Italian wines under the Pio label. (Pio Wines.)

Wesley Wilson is shown here in the mid-1930s with his wife, Emily, center, son Wesley, and an unidentified woman. He was the caretaker for the Shady Hill Country Day School, at 8836 Crefeld Street, which became the lower school of the Stevens School in 1935. The Wilsons lived in the renovated stables, built in 1888, pictured here. Their three children, Emily, Wesley, and William, attended Jenks School. In 1952, Wilson left Stevens to start a landscaping business. (William Wilson.)

Mary Poleri Campbell's Sicilian-born grandparents arranged her parents' marriage in Chestnut Hill. Mary Poleri, seventh from the right middle row, is shown with Lily Miles Jones, to the left of Mary, and Beatrice Magazine, behind Mary, c. 1937. The children are in front of Cope's Drugstore, at 8405 Germantown Avenue, with the pharmacist, Leighton Cope, to the right. Later called Kaback's, the drugstore was a place in which Mary Poleri as a teenager spent hours with her friends, sitting on the stools at the marble-topped soda fountain. (Mary Poleri Campbell.)

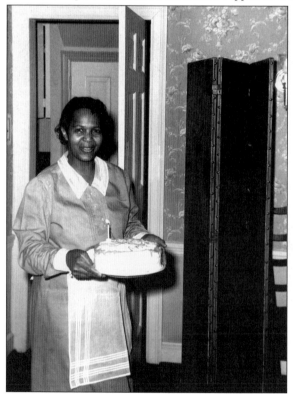

An orphan with four years of schooling, Louise Reid left Virginia for New York City at age 17 to find work. William and Clarissa Melcher hired her to care for their daughters and sent her to cooking school. In 1932, the Melchers moved to Chestnut Hill, and William Melcher lost his job. When the family told Louise Reid that they "couldn't afford her anymore, she said she would work for nothing." They paid her what they could until Melcher found a job. She stayed with them for 52 years. (Sally Jarvis.)

During the Depression, the lives of many children in Chestnut Hill revolved around the Water Tower Recreation Center. There, children learned crafts, trades, tap-dancing, sports, and other games. On the west steps *c*. 1942 are Joe Marchino, Buddy Morasco, Rudy Miles, Alfie Rosa, Jack Morasco, Hugh Cunningham, Wesley Wilson, Jack Galante, Pete Braun, Russell Goudy, John Ciambella, and John Braun. Americans of Italian, Irish, African and other backgrounds grew up playing together in Chestnut Hill. (Buddy Morasco.)

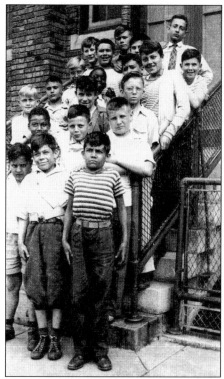

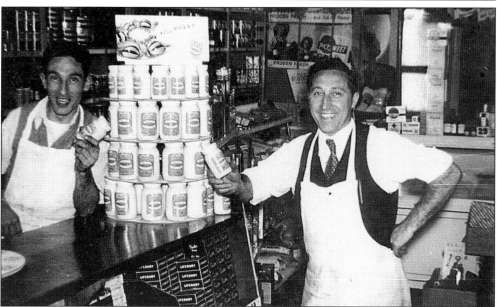

Joseph Galante and his brother Ignatius are pictured here in 1947 in Galante's first store, 8030 Germantown Avenue, rented from the Venetian Club. Galante instituted fixed prices instead of bargaining. He started out as a "cellar boy" at an American Store on Germantown Avenue. He was promoted because his fluent Italian brought in more customers. He earned a percentage of the weekly take. This was an unusual arrangement, as Italians were often denied promotion because of prejudice against them. (Leonard and Elaine Galante.)

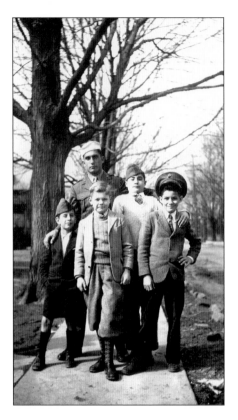

People of all ancestries from Chestnut Hill joined the armed forces during World War II. Here, in February 1945, in front of the Galante home on Ardleigh Street, is Frank Galante, one of five brothers to serve out of twelve siblings. A Marine, he participated in the bombardment of Japan in 1945. He poses with Anthony Galante, Sonny Bucci, Jack Galante, and Buddy Morasco, three of whom proudly sport his Marine Corps hats. (Buddy Morasco.)

Jean McCarthy was the daughter of Dr. Francis McCarthy, who worked at Chestnut Hill Hospital and had an office in his home, at 8820 Germantown Avenue. Without asking her parents, she joined the WAVES (Women's Reserve, U.S. Naval Reserve) and served in communications from 1942 to 1945. Doctors like her father felt the increased burden of the medical needs of the community while younger doctors were overseas. Her mother, Helen Jarvis McCarthy, volunteered as an air-raid warden. (Regina McCarthy Dwyer.)

Six

ARCHITECTURAL
LEGACY

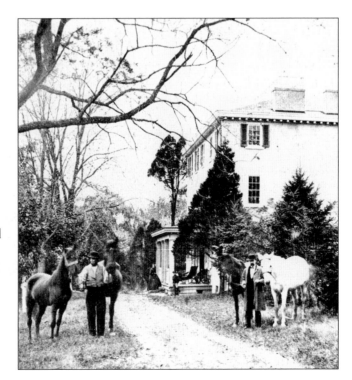

Union Grove, the residence of Owen Sheridan, was along West Highland Avenue near today's Tohopeka Court. Gentleman farmer Sheridan was the wealthiest man in Chestnut Hill in the mid-19th century. Sheridan's estate extended from Rex Avenue to Hartwell Lane and down to the Wissahickon Creek, including the land that is now the St. Martins golf course of the Philadelphia Cricket Club. On the site today is a stone wall with the inscription "O.S. 1845." (Library Company of Philadelphia.)

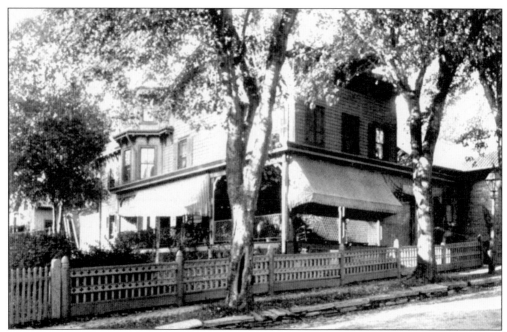

At 41 Rex Avenue stands one of the few surviving early frame houses in Chestnut Hill, built *c.* 1855. Alexander Hare, a blacksmith, owned it in 1857. It became the residence of Daniel S. Hinkle in 1899, when this photograph was taken, and remained so until 1917. The front porch was demolished and the side porch was added in 1896. The building on the right, at 33 Rex Avenue, was replaced by a house probably designed by Theophilus Chandler. (Germantown Historical Society.)

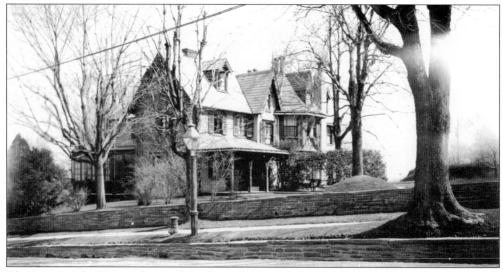

Thomas Ustick Walter designed Inglewood Cottage in the Gothic Revival style at 150 Bethlehem Pike in 1850 for publisher and lithographer Cephas Childs. This was one of the first "cottages" built in north Chestnut Hill for upper-class Philadelphians seeking to escape the city—the beginning of a trend of sophisticated, fashionable houses in this rural community. Walter's architectural career gained national stature in 1833, when he won the competition for the design of Girard College in the Greek Revival style.

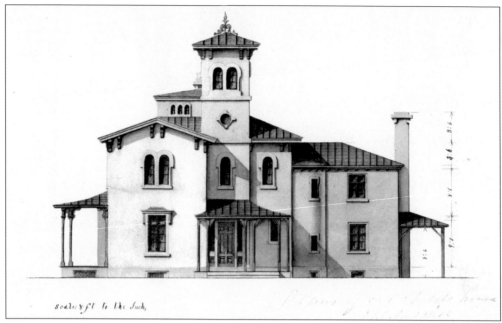

This original drawing by an unknown architect shows Inglewood, built for Cephas Childs c. 1850. Childs was a director of the Chestnut Hill Railroad Company, which brought the first railroad to Chestnut Hill in 1854. This Italianate-style house, at 154 Bethlehem Pike, exists today, but its new owner in 1891, John Story Jenks, hired architects Cope and Stewardson to change it to a Georgian Revival style. Jenks also owned Inglewood Cottage, where his mother-in-law lived.

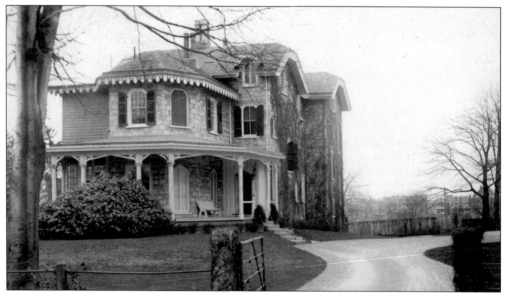

In 1853, Cephas Childs bought 10 acres of land around what is now Prospect Street. His Italianate-style villa was completed c. 1855 at 8410 Prospect Street. In 1884, Joseph Patterson bought the house from Childs for a summer residence and named it Grace Hill. The house was enlarged c. 1888. This photograph was taken after 1904, when two stories were added in the back, but before 1917, when the 8400 block of Anderson Street was constructed.

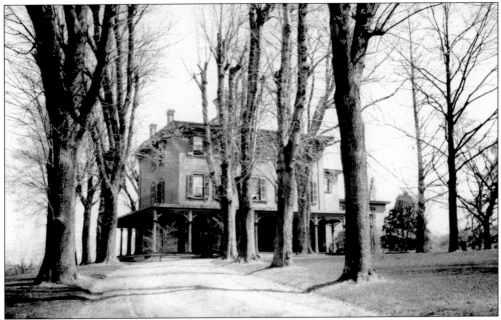

Lanoraie was the home of Col. Alexander and Julia Williams Rush Biddle, on Stenton Avenue, where the Biddle Woods development is today. Julia Biddle's uncle, Henry J. Williams, owned the site originally. Colonel Biddle served on Gen. Ulysses S. Grant's staff during the Civil War and was a banker. Three of the Biddle children, Louis, Marianne, and Lynford, continued to live at Lanoraie for some time. The house burned in 1942. A 19th-century Schwenkfelter cemetery is located at the back of the property.

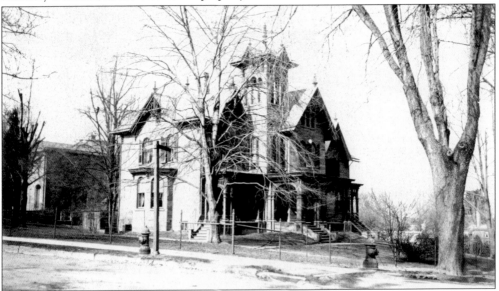

Samuel Sloan designed this house at the corner of Norwood Avenue and Chestnut Hill Avenue in 1861 for developer Charles Taylor. In 1883, George North, a banker and broker, bought the house. The structure behind was constructed in 1887 as a school building for what is now Our Mother of Consolation Church. While the present school building was being constructed, this house was used as the school and then was demolished in 1928.

Cabinetmaker John Peberdy bought five acres along East Mermaid Lane in 1851. He constructed three houses, including 43 East Mermaid Lane, seen here c. 1900. Built between 1861 and 1876, this house had elements of Greek Revival and Italianate architecture, with a templelike pediment and arched windows. The Wehners lived in the house from 1900 to 1970, raising six children there. When they moved in, they used coin-fed gas lighting. When the lights dimmed they fed the meter. (Carol Cameron Sears.)

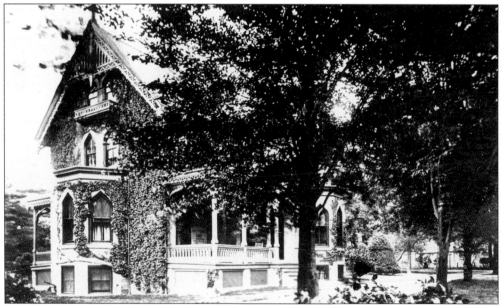

The Eldon Hotel, at Bethlehem Pike and Stenton Avenue, overlooking the Whitemarsh Valley, was built c. 1867 as a summer home. Its unknown architect included characteristically Gothic Revival features, such as pointed, arched windows and a steep roof. Joseph Eastburn Mitchell, the first owner, had a grindstone business in Philadelphia and was a grindstone expert, collecting varying types for the Smithsonian Institution. He exhibited at the Philadelphia Centennial exposition a 30-foot high Doric column made of 58 specimens of grindstone.

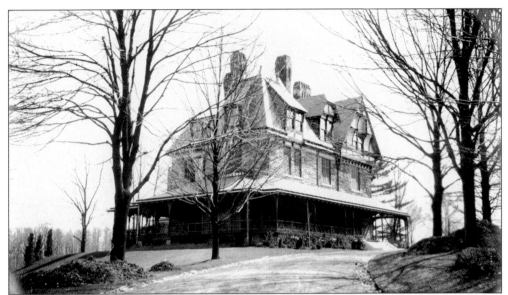

Hillbrow, at 8765 Montgomery Avenue, was designed in 1880 by Frank Furness, the architect of some of the most imaginative buildings in Victorian America. Hillbrow was the summer house of John Lowber Welsh. Welsh and Furness had trained for the Civil War in the volunteer Calvary Troop Company on the present site of Chestnut Hill Academy. Welsh, who lived at 1420 Spruce Street, was a financier and a director of the Philadelphia & Reading Railroad. Hillbrow was demolished in 1916.

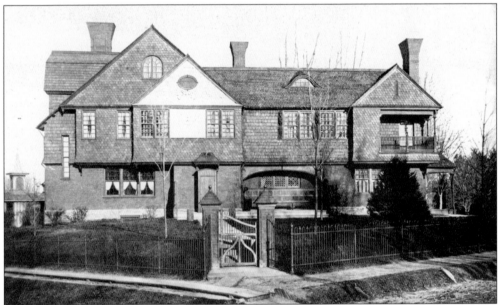

In 1883, Wilson Eyre Jr. designed Anglecot, an exuberant Shingle-style house at Prospect Street and Evergreen Avenue, for Charles Potter. Unlike many other Chestnut Hill houses, the main porch faced the back gardens, rather than the street. The rear of the lot adjoined the property of Potter's father, Thomas. A small porch roof was added in front over the bench area, and some of the windows were altered. The carriage house with cupola, to the left, is no longer extant.

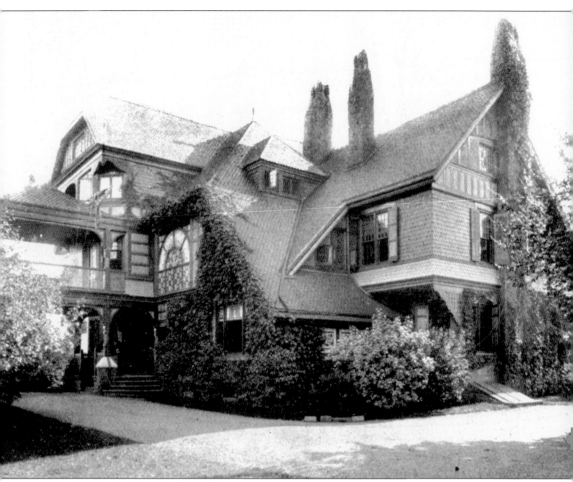

William Potter, another son of Thomas Potter, built the Maples in 1884 at 8250 Stenton Avenue and Gravers Lane. George Pearson was the architect. An observer noted in 1899 that "the tiled roof is all corners, gables and windows . . . striking little windows peep at you. . . . The upper roof of the front slopes to within a few feet of the ground." William Potter took over his father's linoleum and oilcloth business after his father became ill. He later studied law and eventually became ambassador to Italy, in 1892. He had a deep interest in international affairs and, in his Chestnut Hill home, frequently hosted visiting royalty, including Crown Prince Pridi of Siam, who had met the Potters in Europe. Potter lived at the Maples until he died in 1926. The home was demolished in 1969. (Germantown Historical Society.)

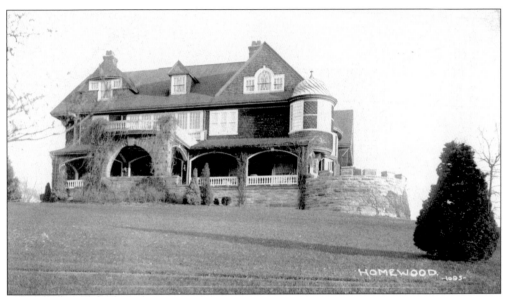

Homewood was the residence of M. Carey Lea, at what is now 9002 Crefeld Street near Laughlin Lane. Collins and Authenreith were the architects of this large Queen Anne–style house, built in 1886. Homewood had a sweeping view of the Wissahickon Creek and the Roxborough hills beyond. Lea, a well-known chemist, had a private laboratory in this house. His best-known publication was *Photography*, a study of the chemistry of photography. Homewood was demolished in 1926 to make way for a Norman-style house designed by Tilden, Register, and Pepper and built in 1930.

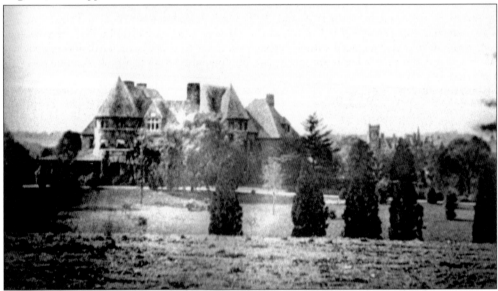

Sallie Houston Henry and her husband, Charles Henry, commissioned New York architects McKim, Mead, and White to design Stonehurst, built in 1887 at Cherokee Street and Moreland Avenue. Stonehurst's 50 acres bordered the Wissahickon Valley and Druim Moir, the mansion of Sallie Henry's father, visible in the distance. The next generation of Henrys settled in other houses, not wishing to live at Stonehurst. In 1940, they demolished the house and later subdivided the land. Stonehurst's few surviving features include tall stone gateposts.

Henry Houston had this stone house built in 1885 at 410 West Chestnut Hill Avenue at the corner of Seminole Avenue, shown here before and after extensive renovations. In 1906, Evan Randolph's parents gave the house to him and his bride, Hope Carson, as a wedding present. After three children were born, Randolph's mother paid to enlarge the house, seen here from Chestnut Hill Avenue between 1910 and 1913. The tree in the foreground and the chimneys above are the only recognizable features of the original property today. In 1913, the original roof was removed and replaced with a steeper roof. Later stuccoed, expanded, and remodeled, the house was transformed as it appears below, photographed from Seminole Avenue between 1913 and 1925.

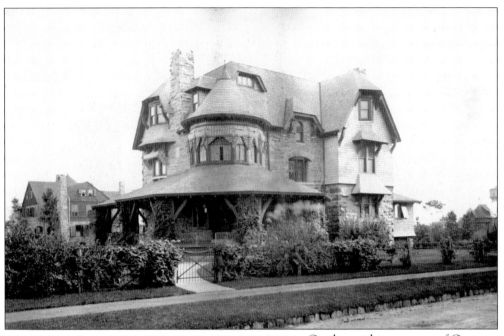

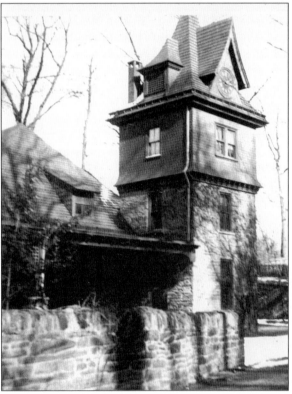

On the southwest corner of Gravers Lane and Crittenden Street is this Queen Anne–style house, designed by Theophilus Chandler in 1888 for George Dunn. In the right background of the 1890s photograph above is the tower of the Gravers Lane train station and, rising above it, the water tower on Ardleigh Street. The house in the left background is 8306 Crittenden Street, also built in 1888. The stone curbs and unpaved roadbed of Gravers Lane are visible. The porch was later removed. Chandler was well known for his sophisticated designs and was the founder of the University of Pennsylvania's Department of Architecture. For Mary Taylor, Chandler designed the carriage house and stable, seen in the image to the left, with a four-story clock tower c. 1881 to accompany the main house, Stonecliffe, on Norwood Avenue. The carriage house, at 1 Caryl Lane, was converted into a residence in 1946.

In 1887, John Worthington designed 121 West Chestnut Hill Avenue for Philip E. Chillman of Chillman and Company, Photography, whose studio was at 914 Arch Street. This romantic rendering with a boy on a pony refers to the notion of healthful country living in the suburb of Chestnut Hill.

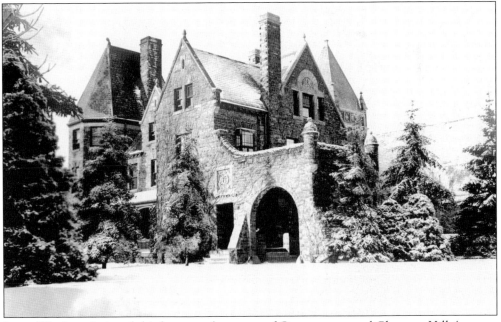

James Windrim designed this house at the corner of Germantown and Chestnut Hill Avenues for Jacob Disston. In this c. 1905 view, a datestone with "1888 AD" is visible on the east facade. Disston's father, Henry, founded Disston saw works and lived on fashionable North Broad Street. His sons moved here to enjoy the new suburban lifestyle. In 1909, Jacob Disston moved to a larger house, Norwood Hall, and in 1914, he subdivided this house into three residences.

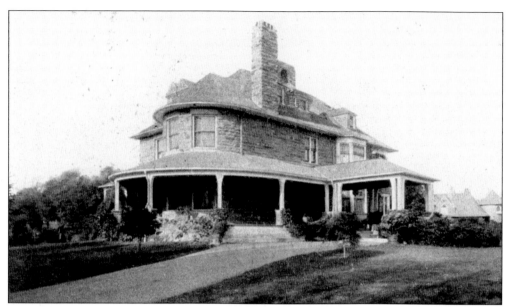

Hazelhurst and Huckle designed St. Martin's, seen here in 1890, at St. Martins Lane and Willow Grove Avenue, for Edgar Sheppard. The roof caught fire in 1907 when a steam-driven toy train tipped over on the third floor. In 1925, the Starkey family replaced the wood porte-cochere on the south side with a stone one. The porch seen here was later removed, and the back part of the house was lopped off along a diagonal. (Germantown Historical Society.)

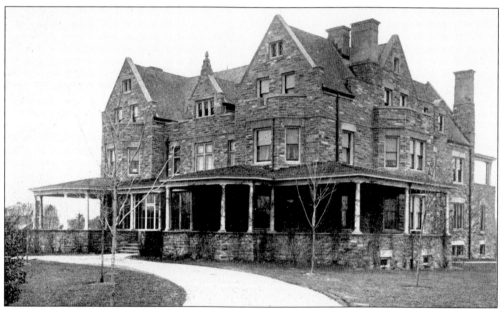

In 1896, Boyden and Taylor (who designed a U.S. Mint building in Philadelphia) designed this house at 416 West Moreland Avenue for Nathan Taylor, the third generation to run N. & G. Taylor Company, a manufacturer of tin plate. Taylor named the house Efnemheim, an unusual name derived from the first letter in each name of his daughters: Elizabeth, Florence, Natalie, Evaline, and Marjorie. He died in 1915. In 1917, the house was replaced with a French-influenced stone dwelling.

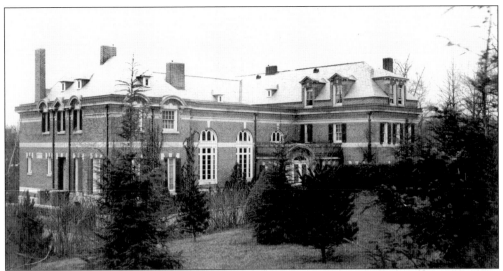

Clarence Zantzinger was the architect of 8440 St. Martins Lane, completed in 1903. Called Kate's Hall, it was the home of the Joseph S. Clark Sr. family and was a departure from most Chestnut Hill homes because it was made of brick. This photograph, taken c. 1906, shows the entrance facing St. Martins Lane. The other facade was masterfully sited facing the Wissahickon. Grand homes like this were intended to house a large family and a staff of servants.

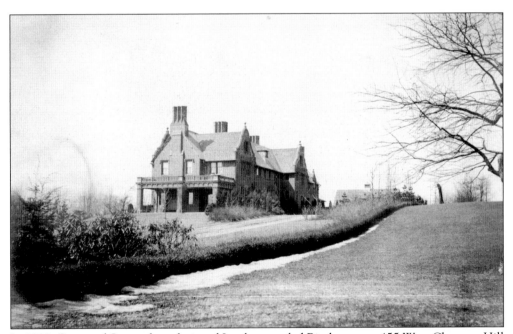

In 1903, Cope and Stewardson designed Jacobean-styled Binderton, at 455 West Chestnut Hill Avenue, for J. Wilmer Biddle, son of Alexander Biddle (see page 98). Pictured c. 1905, the gardens were designed by Olmsted Brothers. Estate owners like the Biddles often traveled, spending months away from their opulent houses. When asked what his sons did, Biddle replied that they had graduated from medical and law school and never practiced, except for Wilmer who "became a famous amateur golfer and practiced all the time."

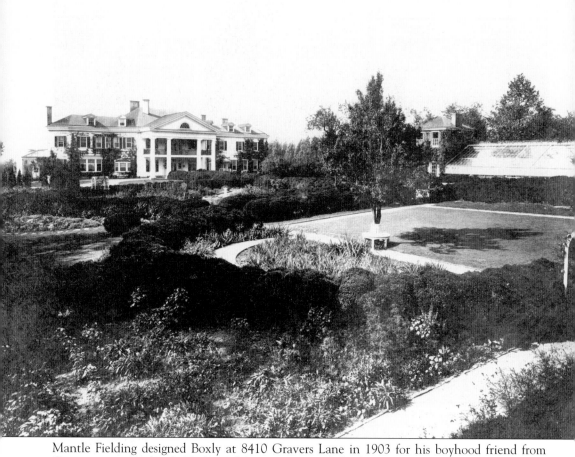

Mantle Fielding designed Boxly at 8410 Gravers Lane in 1903 for his boyhood friend from Germantown, Frederick Taylor, who was renowned for his studies of industrial efficiency. Taylor used its construction as a laboratory to test his theories of labor efficiency. For example, he required his hand-picked men and horses to work and rest in specified intervals. Fielding substantially regraded the site to provide optimum views of the Wissahickon gorge. Boxly was named for the immense 100-year-old boxwood shrubs in the gardens. Only the right side of Boxly survives today. The greenhouse, on the right in this *c*. 1910 photograph, was a conversion of an older building.

Pictured *c.* the 1870s, this building was converted to the Boxly greenhouse. In the 1830s, it was used as a silk manufactory. Now a residence, its address is 8420 St. Martins Lane. Taylor purchased a large part of the Owen Sheridan farm (see page 95), including a third house at 8400 St. Martins Lane.

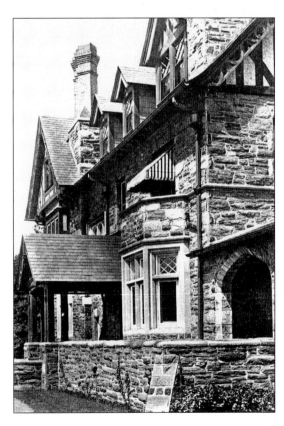

Walter Price designed this Tudor-style house, at 8801 Crefeld Street, in 1904. Alice Kneedler purchased the site, a pasture, from Jacob and Effie Disston. Her husband, Henry Kneedler, was a partner in the textile firm of Kneedler & Company. The porch over the front door, photographed here between 1908 and 1915, has been removed. Price was an authority on the design and restoration of Quaker meetinghouses. He was the brother of architect William Price.

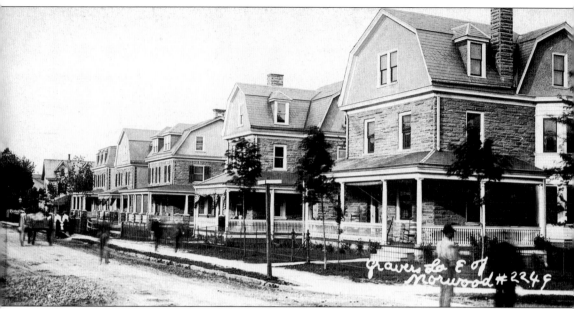

Shown c. 1907 is the south side of the unpaved 200 block of East Gravers Lane, formerly called Union Avenue. George Roth, a carpenter, built scores of houses in Chestnut Hill, including all the houses seen here, except 222, the house second from the left. The first house he is known to have built, c. 1867–1868, was his own home, at 230 East Gravers Lane. Its peaked roof is visible on the left. Roth first operated his house-building business near the Chestnut Hill East railroad station. In 1883, he purchased the lot next to his house and built a two-story barn there. He, and later his sons, ran their business from there until the Depression. The house now at 208 East Gravers Lane is absent here since it was not built until 1919. (Germantown Historical Society.)

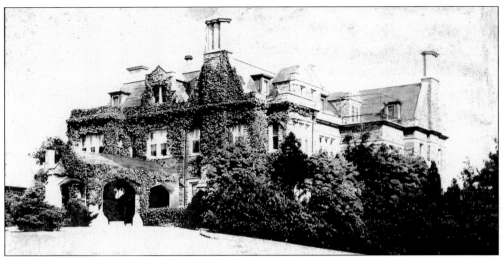

Henry Laughlin, a Pittsburgh steel industrialist, retired to Philadelphia. He hired Pittsburgh architect William J. Carpenter to design Greylock, built in 1909 at 209 West Chestnut Hill Avenue and pictured here c. 1920. The gate lodge at 8838 Crefeld Street marked the main entrance drive to the front of the house. The stone for the exterior walls was quarried on the 10-acre estate. From 1919 to 1922, Laughlin deeded land on both sides of Germantown Avenue to Chestnut Hill Hospital. (Jack Carpenter.)

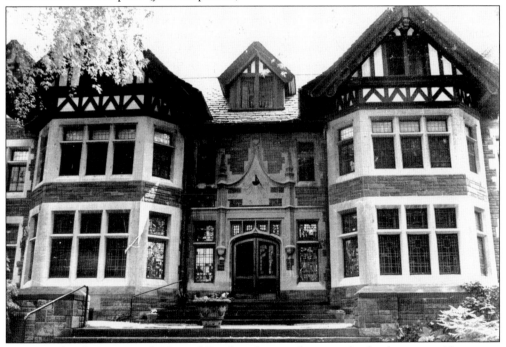

James Frederick Dawson of Olmsted Brothers began planning the landscape on 40 acres at McCallum Street and Mermaid Lane nearly 10 years before construction of Krisheim began for Gertrude and George Woodward. Boston architects Peabody and Stearns designed Krisheim, built from 1910 to 1913. This c. 1914 photograph shows the west facade. The date 1687, over the sundial, refers to the year the first Germanic settlers arrived. They named the area Krisheim (also spelled Cresheim) after their village along the Rhine.

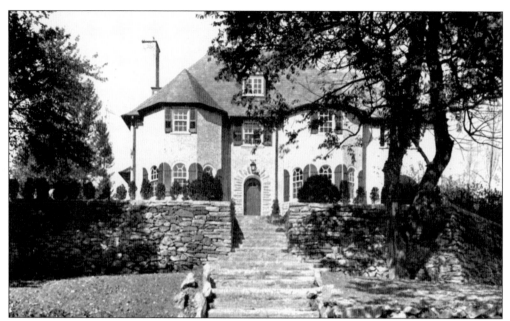

Robert McGoodwin designed this French-inspired house for himself in 1913, at 7620 Lincoln Drive at Cresheim Valley Drive, photographed in 1914. He sited the house on a hill overlooking the Cresheim Valley and used local stone to terrace the lot. McGoodwin leased the land from George Woodward. Woodward hired McGoodwin, H. Louis Duhring, and Edmund Gilchrist to design houses in his planned suburban community in Chestnut Hill, basing their designs on Norman farmhouses and English village designs. (Athenaeum of Philadelphia.)

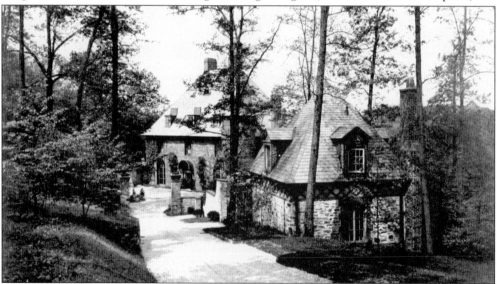

George Howe designed High Hollow, at 101 Hampton Road and Crefeld Street, for his family. Artfully sited, the home stood on land sloping sharply down to the Wissahickon. Howe's romantic country house, completed in 1917, has a rounded turret, a steep roof, large windows, and an interplay of stone and brick. Howe and his partner William Lescaze went on to change the face of modern architecture in 1932 with the completion of the Philadelphia Saving Fund Society (PSFS) building in Philadelphia, America's first modernist skyscraper.

112

Seven
HOSPITALS

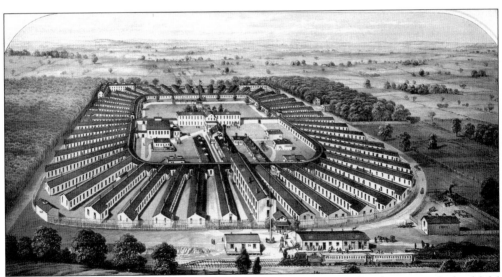

Chestnut Hill, the highest point in Philadelphia, was a destination for clean air and a healthful environment. Pictured is the vast Mower General Hospital, which opened in 1863 to care for wounded Civil War soldiers. The wounded arrived at the Chestnut Hill Railroad station in the foreground, roughly where the Wyndmoor station is today. Occupying 27 acres, the hospital extended from the railroad line to Stenton Avenue. It accommodated 4,500 patients, about three times Chestnut Hill's population at the time.

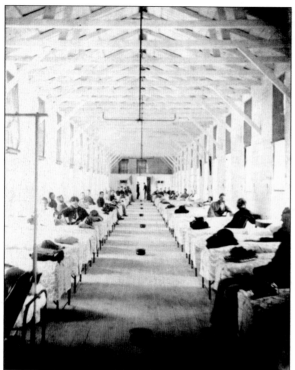

Shown is one of the 34 wards at Mower, complete with spittoons. Food was transported to the wards by handcars on tracks. Most patients were from Pennsylvania because the army tried to place patients as close to home as possible. Luke Lee, a parishioner at St. Mary's Church in Chestnut Hill, lost his arm at the siege of Petersburg in April 1865. He was sent to recuperate at Mower (also called Chestnut Hill Hospital). (Library Company of Philadelphia.)

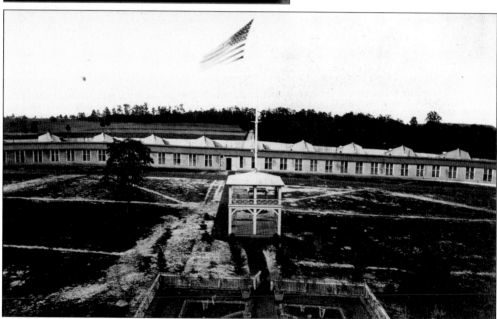

On these parade grounds, a brass band played for the amusement of soldiers. In the distance, cultivated farmland east of Chestnut Hill can be seen. Patients could play cards, pitch quoits, write letters, read, or walk in the chestnut grove. Chestnut Hill residents were known for their charity to the patients. Some soldiers who died at Mower were buried at the Odd Fellows Cemetery at 24th and Diamond Streets. After the Civil War, Mower was demolished. (Library Company of Philadelphia.)

Chartered on November 21, 1903, Chestnut Hill Hospital started in two new twin houses at 27–29 West Gravers Lane. Unable to raise enough money to build a hospital, the seven members of the board of trustees agreed to rent the properties. On October 1, 1904, the board invited the public to inspect the new hospital, which offered men's and women's wards with five beds each, five private rooms, and an operating room. The hospital opened to patients two days later.

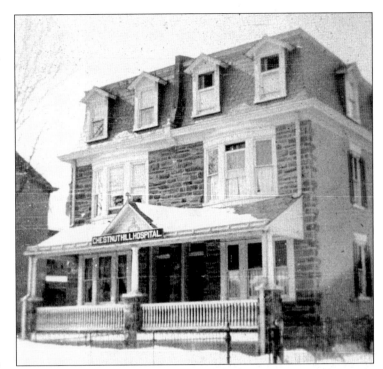

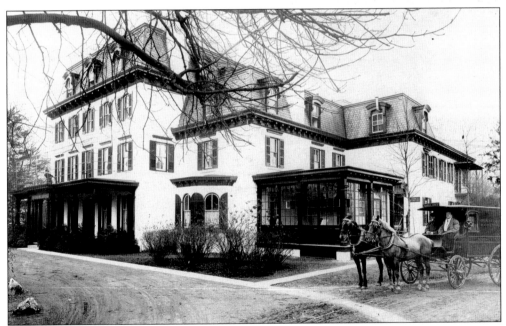

When Chestnut Hill Hospital outgrew its space on Gravers Lane in 1907, the trustees purchased, renovated, and moved into the former Norrington estate, at 8835 Germantown Avenue. This photograph, published in the 1912 annual report, shows the hospital's horse-drawn ambulance, the new sun parlor for the men's ward, and the hospital's newly painted white facade with dark green shutters. (Center for the Study of the History of Nursing, University of Pennsylvania.)

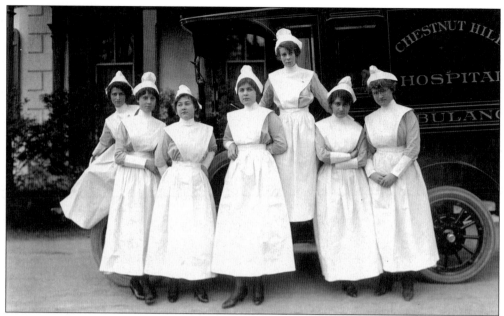

In this 1916 photograph, second-year Chestnut Hill Hospital Nursing School students pose beside the hospital's "automobile ambulance," purchased for the hospital by the Board of Women Visitors in 1914. Each of these young women graduated in 1917 with the exception of Pauline Grotz, second from the right. Because the school did not allow married students, she had to drop out of the program in 1917, when she married Dr. John F. McCloskey, one of the four physicians who opened the hospital in 1904.

In 1906, Abbott H. Chase, a lawyer, founded a sanitarium for "nervous patients" at the recommendation of his brother, Dr. Robert Chase, superintendent of the Friends' Asylum in Frankford. Called the Firs, the sanitarium occupied 12 acres, three houses, and a stable to accommodate a "rest treatment." Abbott Chase and his wife lived in the house shown here, 40 West Bells Mill Road, which was replaced with a new house in 1922, also called the Firs. (Hugh Gilmore.)

116

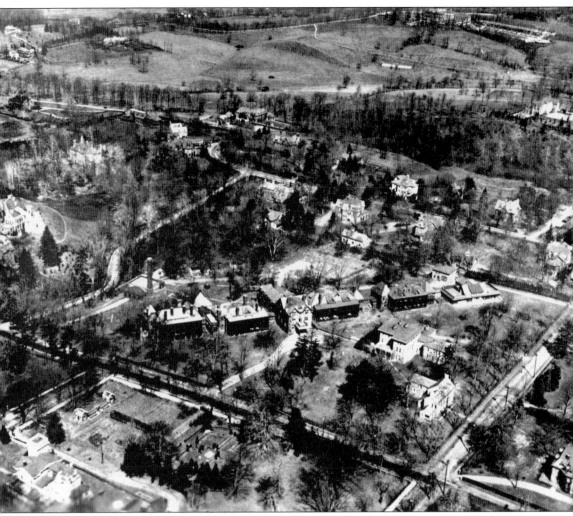

This aerial view, taken in the 1920s or 1930s, features the buildings of the Philadelphia Protestant Episcopal Mission Home for Consumptives, located on Stenton Avenue. Now called Wyndmoor, this area was often referred to as Chestnut Hill until just a few decades ago. Frank Furness designed the main building and the patient dormitories with outdoor sleeping porches, seen in a diagonal row across the center of the photograph. Part of the cure was fresh air in all seasons, so sleeping tents were erected on the property. The large Italianate house adjacent to these buildings was the home of William Bucknell, who in 1885 donated his estate at 8601 Stenton Avenue to be used as the second tuberculosis hospital in the nation. In the top right is Whitemarsh Hall, the palatial mansion of Edward Stotesbury.

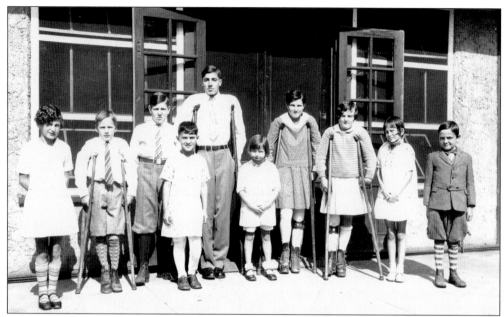

In the 19th century, infectious diseases were an ever-present danger and were killing one out of four Americans *c.* 1900. William Bucknell insisted that care be given regardless of race, creed, or national origin. Between 1877 and 1957, the hospital ministered to thousands of tuberculosis patients. In 1946, the Home for Consumptives became known as All Saints' Hospital for the Treatment of Chronic Diseases. These children were treated for tuberculosis of the bone.

On rainy days, young goggled patients had to sunbathe under ultraviolet lamps, as shown here in the 1940s. In the 1920s, the Home for Consumptives pioneered a treatment called heliotherapy, involving prolonged exposure to strong light for the treatment of tuberculosis of the bone and skin. In the 1950s, the need for tubercular care diminished with the development of antibiotics, and the institution transitioned into care for the chronically ill and aging. (Historical Society of Pennsylvania.)

Eight

THE WISSAHICKON VALLEY

The Wissahickon gorge, with its slopes and rapid streams, provided the means for harnessing the water used to power mills. Today's park was once a thriving industrial corridor, lined with mills. This early view looking south on the Wissahickon Creek shows the wool and cotton mill once located at Bell's Mill Road bridge. James and Isaiah Bell purchased the mill in 1801. In 1818, the county of Philadelphia built a bridge "over the Wissahickon across the ford at Bell's Mill Road."

Today, only the stone wall remains of this 19th-century house, which stood just above the Wissahickon Creek. It was once the home of Edward Megargee, whose brother, Charles Megargee, started the Wissahickon Paper Mill. This successful enterprise stood on the east side of the Wissahickon Creek near the covered bridge at Thomas Mill Road. In 1859, Charles Megargee converted the original gristmill to a paper mill. By the time of this 1911 photograph, the house had been abandoned. (Germantown Historical Society.)

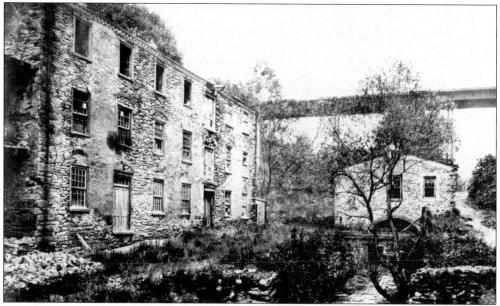

Two abandoned mills, seen here c. 1900, once stood along Cresheim Creek beneath the McCallum Street Bridge. Gorgas's Fulling Mill, on the right, operated between 1725 and 1741. Hill's Mill, on the left, was a cotton factory from c. 1850 to 1879. At one time, there were five mills on the Cresheim Creek. By the early 1870s, Henry Houston purchased the mill sites and gave the land on the lower Cresheim Creek to Fairmount Park. (Free Library of Philadelphia.)

A lady stopped her carriage on a bridge over Cresheim Creek to pose for this 1912 photograph. The stone bridge, which exists today, carries traffic on Cresheim Valley Drive between Navajo Street and Lincoln Drive. The bridge looks much the same today, but the creek's banks are now heavily overgrown. (Germantown Historical Society.)

This rustic wooden bridge, walkway, and pavilion, seen here in 1904, once stood over Devil's Pool just above the confluence of the Cresheim and Wissahickon Creeks. In the background is the Cresheim Bridge, a graceful aqueduct built c. 1900 to carry wastewater from Chestnut Hill to a treatment plant. A series of wooden footbridges were continually rebuilt as they rotted, until the 1960s, when the last one was destroyed by a hurricane. (Germantown Historical Society.)

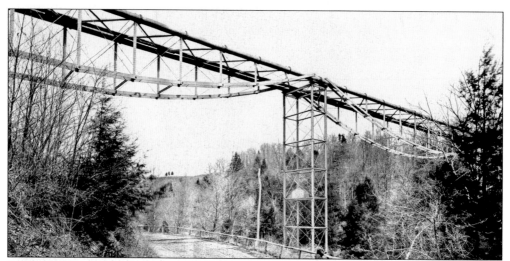

From 1870 to 1891, this pipe bridge carried water to Chestnut Hill from the Shawmont Reservoir in Roxborough. Seen here in 1876, it crossed the Wissahickon Creek just above Livezey Lane. At great peril, youths sometimes crossed the bridge on the two-foot-wide planks, 103 feet above the creek. They occasionally dropped acorns on startled couples below. In winter, the uninsulated pipe froze, cracked, and leaked. In 1891, the bridge was dynamited without forewarning, terrifying passersby. (Union League of Philadelphia.)

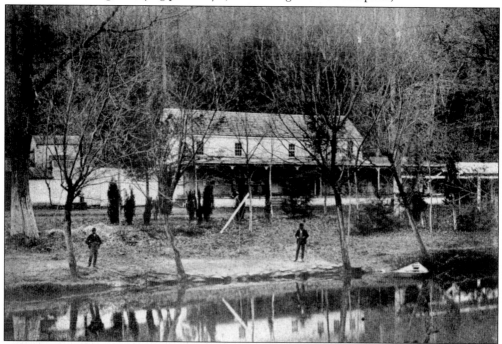

Mills lined the Wissahickon Creek when the Valley Green Hotel, seen here in the 1890s, was built on the Roxborough side c. 1850. Sleighing parties from Germantown and Chestnut Hill held dances here. The Valley Green competed with the nearby Indian Rock Hotel for guests. In 1901, the Society of Colonial Dames renovated the Valley Green Inn, then owned by Fairmount Park, and changed it into a romanticized version of a Colonial inn, which it never was, for use as a café.

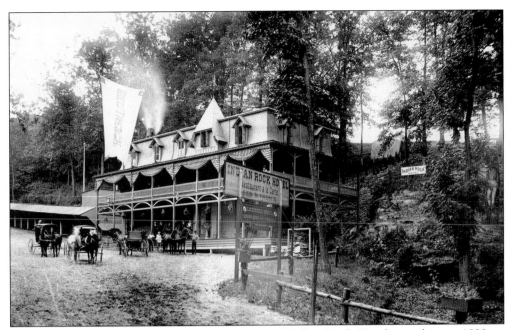

From 1875 to 1880, Reuben Sands built the second Indian Rock Hotel, seen here *c.* 1899, at the foot of Monastery Avenue on the Roxborough side of the Wissahickon Creek. The original hotel was at the foot of Rex Avenue. Fairmount Park acquired this property in the early 1870s and demolished the hotel to restore the park to a natural state. The second hotel was built outside the park so that "spirits" could be sold. It was demolished in 1916.

The Wissahickon Inn opened in 1884, enhancing Chestnut Hill's reputation as an established popular resort. The natural beauty of the Wissahickon gorge drew city dwellers, and the higher elevation of Chestnut Hill made it a few degrees cooler than downtown Philadelphia. Pictured here in 1892 are Mary and Bill Bradley and their friends, scrambling over the rocks in their Victorian finery.

This uniformed Fairmount Park Guard stands beside a WPA-built shelter and station near the Rex Avenue bridge c. 1938. Operating from 1868 until 1972, the Fairmount Park Guards were expected to enforce the law politely by means of "quiet words" rather than force. Some of the guard's initial duties included removing hornets' nests, capturing runaway horses, preventing suicide, and even rescuing a woman who had fainted because of "tight lacing."

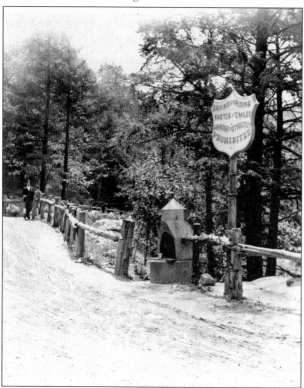

Beginning in 1868, the speed limit within Fairmount Park was seven miles per hour. This was the approximate speed of a trotting horse. Marion Martin Rivinus and a friend raced their horse-drawn sulkies near the Valley Green Inn c. 1910, received citations for speeding, and had to pay a fine. This sign read, "Driving or riding faster than 7 miles an hour is strictly prohibited." Today, the speed limit remains the same along the Wissahickon Creek. (Atwater Kent Museum.)

This rustic Adirondack-style boathouse on a lush wooded setting once stood along the Wissahickon Creek at Compton, the John and Lydia Morris estate, which became the Morris Arboretum. This 1909 photograph shows Lydia Morris in her canoe as she paddles in front of the boat landing located on the east side of the creek, just north of the mouth of the Swan Pond stream. (Morris Arboretum.)

Mary Beckerman Dooley lived at the Valley Green Inn until 1929. She enjoyed riding along the Wissahickon Creek. Posing here with an unidentified friend and clad in riding togs, she has playfully added a hat to her horse's head. Her father, Thomas Dooley, served as the proprietor of the inn and lived there with his family during the early 20th century.

The winter months often bring a spectacular sight to the Wissahickon Valley. Freezing groundwater, seeping through the rocks that project from the steep sides of the Wissahickon gorge, forms curtains of slender icicles. This *c.* 1925 photograph by James Rich captures an image as familiar today as it was to the first people who walked along the Wissahickon. (Library Company of Philadelphia.)

INDEX